ANTWE
NEW YORK

EUGEEN VAN MIEGHEM (1875-1930)
and the Emigrants of the Red Star Line

Cover: At the river Scheldt (detail), 1926
oil on paper, 85 x 100 cm
private collection

right: Eugeen Van Mieghem
photograph, ca. 1902
Antwerp, AMVC Letterenhuis

page 4: The emigrant, ca. 1900
charcoal and red chalk, 61.9 x 42 cm
Antwerp, Municipal Print Room

page 94 above: Emigrants on the gangway, 1912
pastel and charcoal, 47.8 x 61.5 cm
Antwerp, Municipal Print Room

page 94 below: Antwerp Jews, ca. 1904
pastel, 23 x 29 cm
private collection

Antwerp-New York

Eugeen Van Mieghem (1875-1930) and the Emigrants of the Red Star Line
by Erwin Joos

Special thanks to Turlough McConnell and Judith Rodgers for their commitment to this book.

photographer: Joris Luyten
publisher: BAI, Schoten
printing: Blondé, Wommelgem

Copyright © Erwin Joos and BAI, Antwerp 2005

ISBN: 9076704996
D/2005/5751/5

ANTWERP NEW YORK

EUGEEN VAN MIEGHEM (1875-1930)
and the Emigrants of the Red Star Line

By ERWIN JOOS

Table of Contents

1. Antwerp: A Port for All Seasons

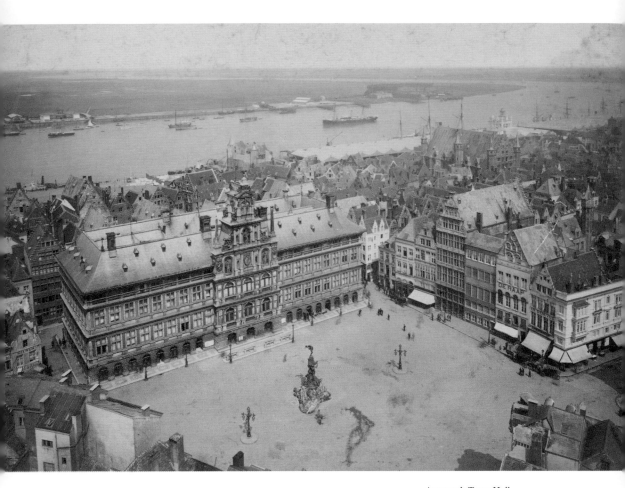

Antwerp's Town Hall
photograph, ca. 1900
Antwerp, Van Mieghem Museum

Early History

According to folkloric tradition, Antwerp takes its name from the legend of a giant named Antigoon, who lived near the river Scheldt and who exacted payment from all those who wished to travel on the river. Antigoon was said to cut off the hand of anyone who refused him. Antigoon's reign of terror finally ended when he was slain by a young hero named Brabo, who cut off the giant's hand and threw it into the river. Hence the name Antwerp, which comes from the Dutch, meaning "hand throw." Honoring the legend is a statue of Brabo and the slain Antigoon on the Grote Markt in front of Antwerp's Town Hall.

Historians and linguists trace the name to the Dutch words, *aanwerpen* or *aanwerven*, meaning to dock a ship. For centuries, Antwerp's

prominence and its ability to sustain economic growth have stemmed from its access to the North Sea through the mighty river Scheldt on which it is located.

The Cathedral of Our Lady is the center of Antwerp and the largest Gothic cathedral of the Low Countries (Belgium and The Netherlands). Its spire, which reaches 123 meters, is the distinguishing feature of the city's skyline. Intended as a fitting demonstration of the city's prosperity, the cathedral took almost two centuries to build; it is a third of its originally planned size. The choirs, built in 1352-1356, are the oldest section; the foundation for the towers was designed by Jan Appelmans and built in 1420 to 1430. This masterpiece of Gothic architecture has seven naves and 125 pillars. Four paintings by Pieter Paul Rubens hang on the cathedral's walls; three of these masterpieces from the 17th century were painted especially for the cathedral.

The Golden Age (16th Century)

During the sixteenth century, Antwerp was the center of continental Europe. By 1560, the peak of the city's period of phenomenal growth, the population reached 100,000. The city's prosperity was the result of various forces: the decline of earlier commercial centers such as Bruges and Venice after the discoveries of Columbus and Vasco da Gama, and the natural deepening of the western opening of the Scheldt into the North Sea. Access to the shipping routes from the New World produced an explosion in the commercial importance of Antwerp, which had been a trading port during the Middle Ages primarily for the exchange of goods among the nation-states of western Europe. Now, with merchandise arriving from the New World, merchants of every nation streamed into Antwerp. Among them were the agents of the Hanseatic League and

A view of Antwerp, ca. 1925
oil on canvas, 60 x 100 cm
Antwerp, Van Mieghem Museum

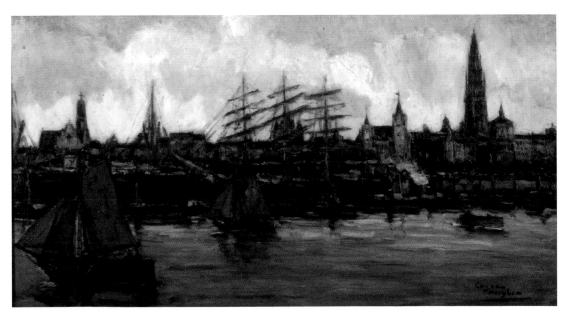

the merchant explorers of England, who based their activities in Antwerp, which quickly became the banking center of Europe. The Fuggers of Augsburg maintained operations in Antwerp, loaning money to the cities and monarchs of the continent. There were times during this Golden Age when a thousand vessels were anchored off Antwerp, and one hundred came and went daily.

As the commercial metropolis of Europe, Antwerp of necessity became an international city. In 1406, Antwerp was reabsorbed into the duchy of Brabant and was governed by an oligarchy of wealthy families who were forbidden to engage in trade. Because of this, and because it lacked a long-distance merchant fleet, the economy of Antwerp was controlled by foreigners whose presence was wisely tolerated. Ships from the major ports of continental Europe and beyond met in Antwerp to exchange goods.

Antwerp's economy experienced three boom periods during the 16th century. The first was based on the pepper market; a second was launched by American silver coming from Seville that ended abruptly with the bankruptcy of the Spanish economy in 1557. The industrial production of textiles led to a third boom after 1559. These boom-and-bust cycles, with the corresponding inflationary pressures, squeezed Antwerp's working class. These economic stresses, coupled with the profound religious revolution of the Reformation, culminated in violent riots in August 1566. The conciliating presence of the regent Margaret, Duchess

Sailing ships at the quay, ca. 1925
oil on canvas, 47 x 71 cm
private collection

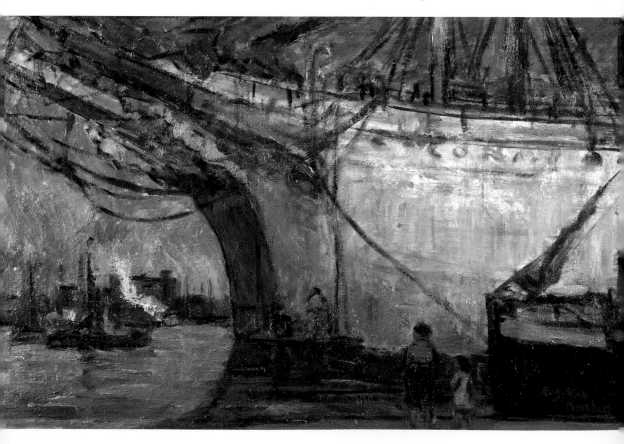

of Parma, was swept aside the following summer, when Philip II installed the Duke of Alva to restore order with a military regime. The Eighty Years' War broke out in earnest in 1572, essentially terminating commercial communication between Antwerp and the Spanish port of Bilbao. On November 4, 1576, Spain captured Antwerp and within three days nearly destroyed it. The Golden Age of Antwerp is officially considered to have ended when the city was captured by Alessandro Farnese in 1585.

The decline in Antwerp's prosperity during the last three decades of the sixteenth century, with its terrible politico-religious warfare, was finally complete with the signing of the Treaty of Westphalia to end the Thirty Years' War (1618-1648). The Treaty contained a clause in the interest of Holland that allowed for the closing of free navigation on the Scheldt. For the succeeding generation, Antwerp's banking interests were controlled by Genoa and its mercantile supremacy passed to Amsterdam, with the exodus of population for religious and economic reasons to the northern part of the Low Countries. By holding the mouth of the Scheldt, the Protestant rebels succeeded in relegating Antwerp for centuries thereafter to the status of an inland port.

In his book, *The Hebrew Portuguese Nations in Antwerp and London at the Time of Charles V and Henry VIII,* Aron di Leone Leoni tells the fascinating story of the "New Christians," Jews subjected to forced conversions in Spain and Portugal, and the important role they played in the development of Antwerp as a center of trade. Their influence began early in the sixteenth century, when a small group of Spanish and Portuguese Jews, the so-called Sephardic Jews, settled as merchants in Antwerp. Later referred to as Marranos, most of these New Christians remained faithful to Judaism and practiced their religion in the privacy of their homes or in secret synagogues. In his description of the Low Countries (1567), Guicciardini stated that the development of Antwerp as a commercial "emporium" could be attributed to flourishing spice trade. Beginning in 1503, the entire harvest of pepper and other spices was shipped from the Portuguese East Indies to Antwerp via Lisbon. Other valued colonial products included precious stones, Brazilian wood and pigments, sugar, tin and silver. By the 1520s the spice trade had passed under the control of a consortium led by a Sephardic merchant, Diogo Mendes.

Of Spanish birth, Diogo Mendes (ca. 1492 - ca. 1542) and his brother built a business trading in spices and precious stones. He settled in Antwerp and when his brother died in 1536, he was joined in business by his sister-in-law, Beatrice da Luna (Gracia Mendes). Their huge enterprise enjoyed a monopoly in pepper. Through their associates in Lisbon, they bought all the colonial products from the King of Portugal and distributed them from Antwerp to other countries in Europe. Diogo Mendes lived in a palace with dozens of commercial agents, clerks and stewards, many of whom had converted from Judaism. In a country where Jews were not permitted to reside, they had no choice other than to declare themselves Christians; many were persecuted anyway, on the suspicion of practicing their religion secretly. Their vast wealth and culture gained them entry into the highest circles of society. Mendes made large loans to the governments of the Low Countries, Portugal and England. He organized an escape route for Marranos from Antwerp to Italy and Turkey. He was arrested in 1532 and charged with practicing Judaism but the case was settled with the payment of a heavy fine (in part due to the intervention of England's Henry VIII, a customer of the Mendes bank). After his death in Antwerp a similar charge was the pretext for the confiscation of his property.

When the Inquisition became intolerable the Sephardic Jews left Antwerp for other cities of Europe, such as Ferrara (Italy) and Amsterdam

The Willemdock
photograph, ca. 1900
Antwerp, Van Mieghem Museum

(Holland). Under the influence of their new inhabitants and the rich traders from Antwerp (such as Dierck van Os, Balthasar de Moucheron and Willem Usselinx), cities in Holland became the main sponsors of ventures to the Indies. The profits from these explorations triggered a vigorous "race" for those riches. To minimize the risks of competition, the Vereenigde Oost-Indische Compagnie (VOC) was founded in 1602. The trading and colonizing company, the Dutch West India Company, was chartered by the States-General of the Dutch republic in 1621 and organized in 1623. The company was initially interested in taking Brazil from the Portuguese. However, after 30 years of warfare, Brazil was lost. However, by that time the company had other accomplishments, having built Fort Orange (1624) on the site of Albany, New York; Fort Nassau (1624) on the Delaware River; Fort Good Hope on the site of Hartford on the Connecticut River; and Fort Amsterdam (1626) on the southern tip of Manhattan island—the nucleus of the settlement called New Amsterdam, now New York City.

The Dutch West India Company owes its charter to Willem Usselinx (1567-1647). Born in Antwerp to a family already active in the spice trade, Usselinx was sent to Spain, Portugal and the Azores for his education. After returning from the Azores in 1591, Usselinx left for Holland. Knowing how much of Spain's wealth was coming from the Americas, he persuaded the Dutch to settle colonies in the New World. After 30 years

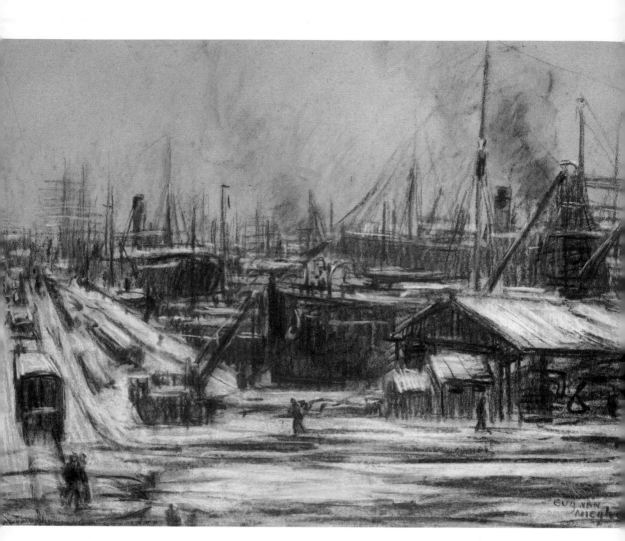

of his persistent—even stubborn—pleas, the Dutch West India Company was finally formed in 1621. As a result of Usselinx's efforts, the Nieu Nederlandt, a ship chartered by the West India Company, arrived in sight of Manhattan island in May of 1624.

The vessel carried about 30 Belgian families, who soon dispersed. After being left on Nut Island (now Governor's Island), eight people moved quickly to the lower part of Manhattan, where they erected a fort on the site of the current Battery Park. Four couples and eight men were sent to the Delaware River, where they also built a fort (near the present town of Gloucester, New Jersey). Two families and six men were sent to Connecticut, where a small fort was built on the site of the present city of Hartford. About eighteen families remained on the Nieu Nederlandt and sailed further up the Hudson. They finally landed near the present city of Albany, capitol of New York State.

Of the families who settled on the southern tip of Manhattan, most were French-speaking Protestant Walloons, from southern Belgium.

Winter at the port, ca. 1912
pastel and charcoal, 48 x 62 cm
Antwerp, Municipal Print Room

In 1626 Pierre Minuit (1580-1638), the son of a farmer from Ohain in Wallonia who was born in Wesel, Germany arrived in Fort Amsterdam as Director of the colony Nova Belgica. Minuit's Walloon family was one of many Protestant families who fled the Spanish government of the Netherlands and found refuge in the Protestant areas of Germany and the Netherlands. He is most famous for purchasing Manhattan island from the Native Americans on May 24, 1626.

In 1653, under the leadership of Peter Stuyvesant, New Amsterdam with its 800 inhabitants, received the right to self-government. In August 1664 Stuyvesant was forced to hand over the colony to England. Both the colony New Netherland and the capitol New Amsterdam were later renamed New York.

The first Jewish congregation of the City of New York was founded in 1654. Its founders were twenty-three Jews, most of Spanish and Portuguese birth, who had been living in Recife, Brazil. When the Portuguese took control of Recife from the Dutch and brought with them the Inquisition, the Jews left Recife. Some of those who originated in Amsterdam returned there; others journeyed on. Initially Governor Peter Stuyvesant did not encourage Jews to settle in the colony. His superiors in Amsterdam, however, soon forced him to rescind his edict, giving as one of their reasons "the large amount of capital which they have invested in the shares of the Company."

Antwerp's Most Famous Ambassador: Peter Paul Rubens (1577-1640)

Widely recognized as one of the foremost painters in the history of Western art, Peter Paul Rubens was the most renowned Northern European artist of his time. Rubens's accomplishment was to invigorate the Northern European style with a marriage of the realistic tradition of northern Europe with the imaginative freedom and classical themes of the Italian Renaissance.

Rubens was born on June 28, 1577, in Siegen, Germany, where his family lived after fleeing Catholic Spanish-dominated Antwerp because of the ardent Calvinism of his father, Jan Rubens. After the death of Jan Rubens, his widow Maria Pypelinckx moved her family back to Antwerp, where they became Roman Catholics.

Rubens's mother had her son apprenticed early to the important painters of Antwerp. In July 1600 he became court painter for the Duke of Mantua, who was an art lover and a collector, especially of paintings. On his travels through Italy on behalf of the Duke Rubens was able to see and study the works of Italian masters such as Carracci, Titian, Raphael and Michelangelo. His employ with the Duke lasted eight years and took him to Spain in 1603, when he accompanied a collection of paintings and gifts sent by the Duke to King Philip III.

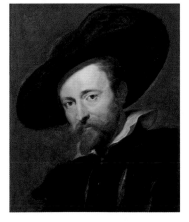

Peter Paul Rubens, Self-portrait
ca. 1630
oil on panel, 61.5 x 45 cm
Antwerp, Rubenshouse

After his return to Antwerp in 1608, he fell in love with Isabella Brant and married her a year later. Soon after, Rubens was named "painter at the court" by the Archduke Albert and Archduchess Isabella. By 1609 he had

been commissioned to paint for the lord Mayor of Antwerp, Nicholas Rockox. In 1611 Rubens and his wife moved to a house that he transformed into an atelier. It was here that most of his works, such as religious altarpieces, were created. Because of his reputation as a master painter he began receiving more international orders and soon became known throughout Europe. Because of the demand for his art Rubens had to rely more and more on the students who worked with him in the studio. From 1616 to 1621, the painter Anton Van Dijck was one of his most talented and creative students.

In the mature phase of his career, Rubens either executed or supervised the execution of a comprehensive body of work spanning all areas of painting and drawing. He imbued his many religious paintings with the devotional quality that characterized his Roman Catholic faith. This emotional religiosity is matched by deep involvement in public life that lends a conservative cast to his painting. Yet Rubens, for all his allegiance to his faith and to the Italian Renaissance, was anything but sterile and academic; indeed, his painting is infused with intense energy and movement with glowing color and light. A love of monumental forms and dynamic effects is apparent in his 21-painting cycle that chronicled the life of Marie de Medicis, originally commissioned for the Luxembourg Palace in Paris.

Rubens also served as occasional diplomat for his patrons, the Archduke Ferdinand and the Archduchess Isabella. He accepted a mission to the Spanish king in 1626, perhaps in part to escape his grief over the death of his wife. Two years later he undertook a diplomatic mission on behalf of the Spanish King Philip IV to the English King Charles I, during which the painter helped to negotiate a peace treaty between England and Spain. Charles I was so impressed with Rubens's efforts that he knighted the painter and commissioned his only surviving ceiling painting, *The Allegory of War and Peace* (1629), in the Banqueting House, Whitehall Palace, London.

After his return to Antwerp in 1630 Rubens married the 17-year-old daughter of his friend and tapestry merchant Daniel Fourment. His new wife Hélène bore him 5 children. During the final period of his life, Rubens painted more and more portraits, genre scenes, and landscapes. His later works lack the turbulent drama of his earlier paintings but reflect a masterful command of detail and technical skill. Despite recurring attacks of arthritis, Rubens remained exceptionally prolific throughout his last years, which were spent largely at his estate, Chateau de Steen. He died at age 64 and is buried in his parish church of St. Jacob in Antwerp.

Out of the Stranglehold (1790-1813)

Steamer in dry dock
postcard, ca. 1902
Antwerp, Van Mieghem Museum

After the French Revolution the French armies gained control over the Low Countries and the Paris National Convention issued a decree on November 16, 1792, proclaiming the freedom of navigation on the Scheldt. It was more than two years before a foreign vessel, a Prussian three-master, entered the port, followed three days later by a Genoan vessel. This time the Dutch and Zeelanders no longer remained inactive.

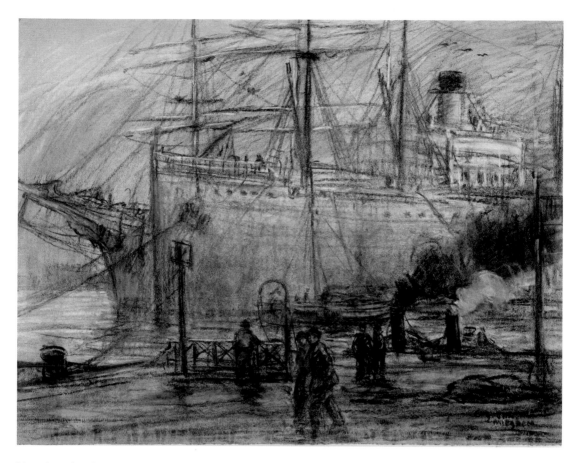

Moored vessels and tugs, ca. 1912
pastel and charcoal, 47.7 x 61.6 cm
Antwerp, Municipal Print Room

At the end of April an American and a Danish ship, both coming from Bordeaux, were stopped by the Zeelanders in Flushing. As soon as the French commander Pichegru had conquered Holland, a treaty was signed at The Hague (March 17, 1795), proclaiming the freedom of navigation on the Scheldt. The coup of November 9, 1799, made Napoleon First Consul in France; a month later he enacted a series of measures to protect and encourage the shipping interests of neutral countries. Antwerp's shipping business now increased rapidly.

With the re-opening of the Scheldt, interest soon grew in the German interior for the organization of import and export via Antwerp. Representatives of large German, Dutch and even American firms soon established themselves in the city. On May 7, 1801, an American ship from New York entered the port, thus restoring trans-Atlantic communications after more than two centuries. An inspection visit by Napoleon himself (July 18-20, 1803) gave the signal for a series of modernization efforts. Napoleon fully appreciated the great strategic importance of the port, which he considered: " ...a pistol aimed at the heart of England".
He ordered the building of an arsenal and military wharf next to a secured dock, and of a quay along the Scheldt 1,640 yards long to connect northern and southern installations. Unfortunately, the outbreak of war between France and England in 1803 thwarted the rosy prospects.

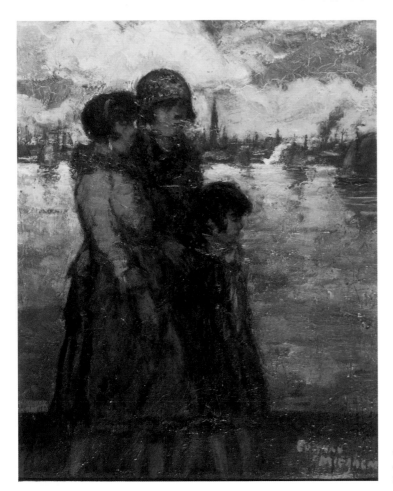

Walking, 1927
oil on canvas, 47 x 38 cm
private collection

During the second half of 1803 only 46 ships sailed into the port.
The incoming sugar and coffee traffic was now lower than in the previous
year. Portugal, which supplied colonial goods from Brazil, and the United
States in particular profited from the war. The Americans bought colonial
goods from the French, Dutch and Spanish colonies in Central America
and sailed to a North American port. The papers were then changed so
that these "enemy" cargos could pass the English inspection fleet under
a neutral flag. The English, who were aware of these practices, condoned
the delivery of these supplies to the Continent because the American
ships usually bought industrial products in England for their return
journey. Antwerp suffered from these commercial reprisals exacted by
France and Great Britain in their grim fight for economic hegemony.

In 1805 the Americans dominated Antwerp port activity. Their ships
arrived en masse not only from the United States, but from the
Netherlands East Indies and Canton, China, as well. While the European
powers were steadily wearing each other out, the Americans took over the
colonial trade. Notwithstanding the war, 1805 proved a good year for
Antwerp. But on November 21, 1806, Napoleon issued the Berlin decree,

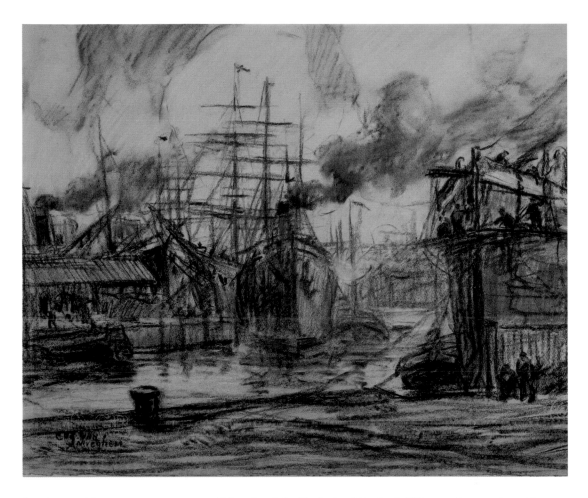

Steamboats and three-masters
at the dock, ca. 1912
pastel and charcoal, 47.9 x 62 cm
Antwerp, Municipal Print Room

overleaf:
Winter at the Kattendijk dock, ca. 1912
oil on paper, 51 x 70 cm
private collection

which ordered the blockade of England. This soon destroyed maritime trade completely. Between March 17 and July 21, 1808, seven American ships were embargoed. Before reaching Antwerp, they had sailed into an English port. Napoleon personally issued the order confiscating the ships and their cargos. On December 20, 1807, the American government, fearing international consequences, forbade American ships from sailing to Europe. As a result, Antwerp was again demoted to an inland port when Napoleon occupied the northern Netherlands. The only positive development during these gloomy times was the continued expansion of port infrastructure. Two docks, the small dock (later called Bonaparte dock) inaugurated January 1, 1811, and the large dock (later called Willem dock) inaugurated November 29, 1812, were excavated.

After Napoleon's defeat at Leipzig in 1813, the French Empire soon collapsed. It soon became apparent that the European superpowers wished to unite the XVII Provinces of the Netherlands and the Principality of Liège in order to create a buffer state against defeated France. For Antwerp, this implied free trade between the northern and the southern Netherlands, unhampered navigation on the Scheldt and the opening of Dutch colonies for trade. Between 1820 and 1829, on the eve of the

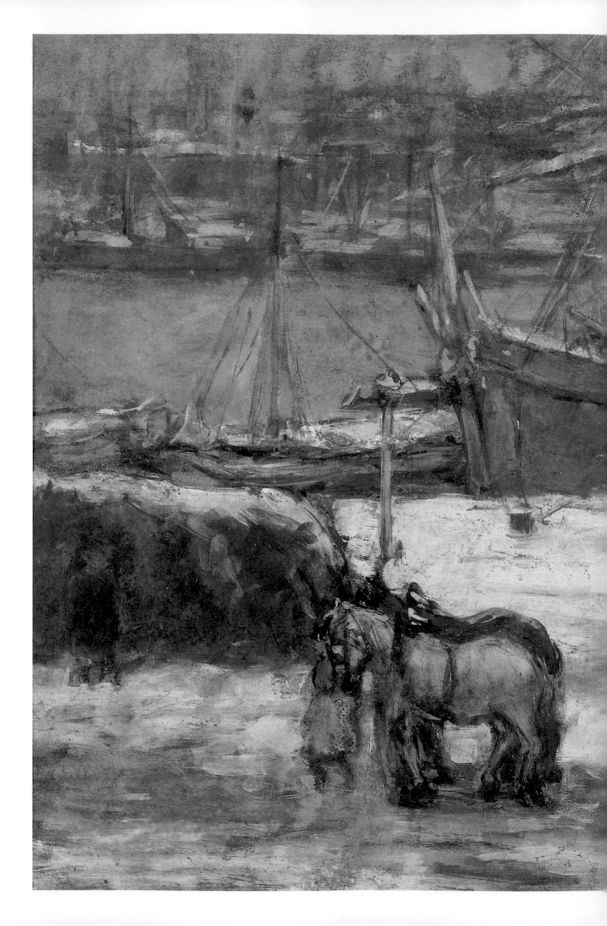

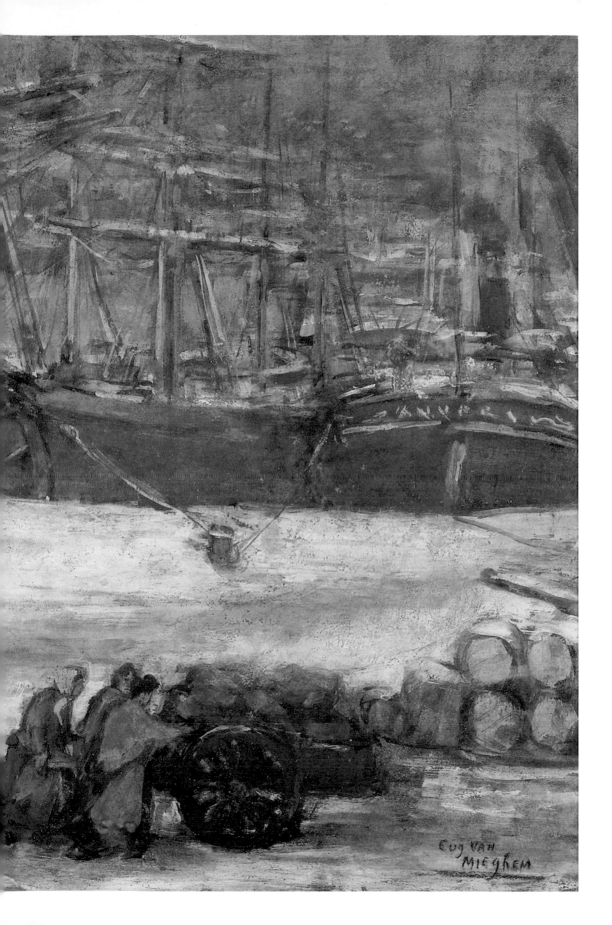

Belgian revolution, ocean-going trade via Antwerp had become larger than that of its Dutch rivals Amsterdam and Rotterdam combined. Antwerp had a monopoly in the coffee, sugar, cotton, rice and hide trades. The port was the undisputed master of South American and West Indian shipping, except for Dutch colonies and previous possessions. During the French period Antwerp had already established brief but good relations with North American ports and these were revived after 1814. Except during lean years such as 1822 and 1824 more American ships sailed to Antwerp than to Amsterdam. On May 7, 1817, the first regular steamer service between Antwerp and Rotterdam was begun. But after a few weeks, due to technical problems, the service was discontinued.

Antwerp, the Kattendijkdock
postcard, ca. 1912
Antwerp, Van Mieghem Museum

The contribution of foreign human capital cannot be ignored. When the French left Antwerp, representatives of German and other foreign firms, such as Kreglinger and Malinckrodt, soon replaced them, demonstrating that enormous profits could be made in maritime trade. In 1750, in Amsterdam, the Bunge family had started trading hides, spices, and rubber from Dutch overseas colonies. In 1850, after a century of lucrative trade, Charles Bunge moved the family business to Antwerp. Charles's two sons established a merchant monarchy straddling the Atlantic. Edouard Bunge stayed in Antwerp, and Ernest Bunge emigrated to Argentina in 1876. With his brother-in-law George Born, Ernest established the firm Bunge and Born. In 1897, a Mannheim grain trader by the name of Alfred Hirsch joined the firm in Buenos Aires and later diversified a large share of its capital into Brazil and the United States.

The Storm of the Belgian Revolution (1830-1850)

The Belgian revolution and its aftermath had a lasting effect on the city of Antwerp. With the departure of the Dutch army from the city after

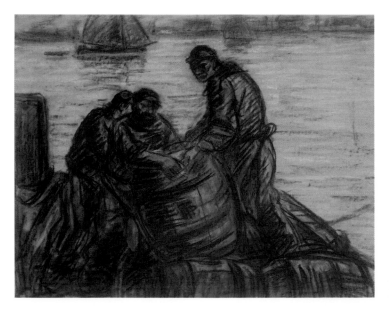

Unloaders of barrels, ca. 1912
pastel and charcoal, 48 x 62.8 cm
Antwerp, Municipal Print Room

Unloaders of a trans-Atlantic ship
postcard, ca. 1903
Antwerp, Van Mieghem Museum

Resting on the Scheldt dike, ca. 1912
pastel and charcoal, 47.9 x 62 cm
Antwerp, Municipal Print Room

December 23, 1832, the long diplomatic struggle for a free Scheldt began anew. Within a few years there was renewed interest in steam navigation to and from Antwerp, as Belgium needed regular connections with the main world ports. The interest extended beyond Belgian export-oriented industry: in order to attract traffic from and to Germany, regular sailings had to be organized and guaranteed from Antwerp as a necessary complement to the rail link between Antwerp and Cologne. The Belgian and German managers of the railway companies demanded this of the Belgian government by submitting a plan that provided for the purchase of 9 passenger liners: 5 for the route to London and Hamburg and 4 for a trans-Atlantic route to New York. The Antwerp Chamber of Commerce was receptive but declared that the line to New York be given top priority, with a company established as the beneficiary of government aid. On June 19, 1840, the Belgian Parliament voted an annual subsidy of BF 400,000.

On March 17, 1841, the government bought two vessels from an Anglo-American company. One of them, the President, sank while being delivered. The second, the British Queen, a passenger liner weighing 2,250 tons - gigantic in its day - arrived in Antwerp on September 9, 1841.

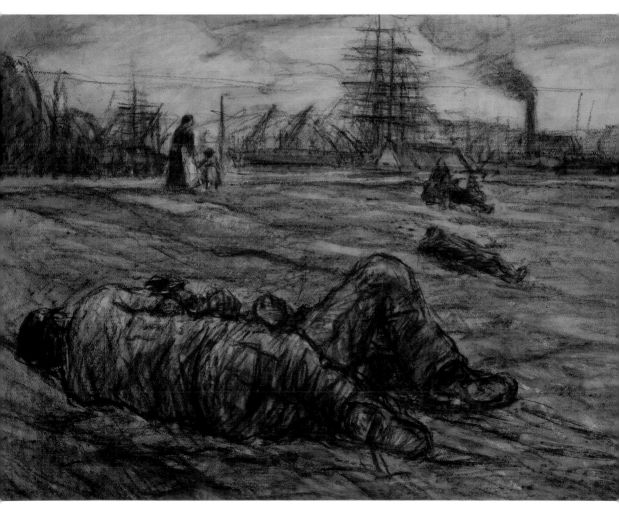

On July 7, 1842, the British Queen left on its maiden voyage to New York.

The Kattendijkdock with the Manhattan
postcard, ca. 1900
Antwerp, Van Mieghem Museum

Unfortunately, the high hopes for the service were soon dashed. When the ship was severely damaged by a storm during its third crossing, the management wisely decided to interrupt the service. In less than one year a deficit of BF 540,000 had been recorded. However, during this period the Belgian government had also started to grant subsidies to regular lines using sailing vessels. On February 27, 1841, a line to New York was opened and in October 1843 the Antwerp-Cologne railway line, the connection between the Scheldt and the Rhine, was inaugurated. As a result Antwerp became a crucial port for both German and Belgian imports and exports. The experiment was extended in 1842 with regular sailings to Vera Cruz and Valparaiso via Rio. By 1844 Antwerp had seven regular long-distance shipping services; New York was the number-one destination, with 8 annual sailings!

Between 1830 and 1850 Antwerp concentrated mainly on America for its non-European arrivals. South and Central America remained important but the greatest gains were in traffic to and from the United States. Vessels bearing the U.S. flag captured a large part of the Belgian markets for their own goods by capitalizing on the interruption of the direct supply of colonial products from the Dutch East Indies. In 1840 record levels were reached, with the arrival of 22,850 tons from the United States. The profitability of this route increased dramatically in the following years, when ships became crowded with an unexpected return freight: namely, emigrants from Europe to the United States.

Menu card, Hamburg-America Line
21 September 1904
Antwerp, Van Mieghem Museum

Responsible for this emigration traffic was push and pull factors operating simultaneously: the relative overpopulation of some European countries, attracted by the apparently unlimited possibilities of life in America. Thousands gathered their meager possessions and went to the Western European ports to cross the Atlantic, embarking initially from Bremen and Le Havre. The port of Antwerp also tried to profit from the emigration traffic. In 1837 the Chamber of Commerce appealed to the Belgian government, noting the stream of emigrants - some 12,000 to 15,000 per year - who embarked in Bremen and who represented an attractive source of income for local trade and shipping operations. The Chamber recognized that Antwerp was not yet sufficiently competitive in this market. The Antwerp-Cologne railway line would become the decisive factor. In 1843 this exclusive Antwerp connection was operating successfully and efficiently. The Chemin de fer Rhénan and Belgian National Railways granted a 30 percent discount to emigrants traveling from Cologne to Antwerp as well as the carriage of luggage. Thus, an attempt was made to divert to the port of Antwerp the stream of emigrants coming from the south of Germany via the Rhine to Cologne. This diversion was immediately successful: in the year 1843 over 3,000 emigrants embarked in Antwerp. In the succeeding years, the operation was regularly improved and enhanced. In February 1846 an inspector was appointed to supervise the reception and embarkation of the emigrants. The Service des Emigrants was set up by Royal Decree of March 14, 1850. This service required the investigation of the seaworthiness of every emigrant vessel, checks on whether the vessels were overloaded and whether sufficient food and water were on board.

The Oceanic (White Star Line) leaving
New York
postcard, ca. 1905
Antwerp, Van Mieghem Museum

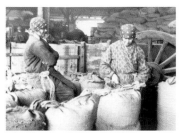

Women of the port
photograph, ca. 1920
Antwerp, City Archives

The girls of the docks, 1922
watercolor, 51 x 76 cm
private collection

In the competitive battle among Bremen, Le Havre, and Antwerp - and to a lesser extent Rotterdam - the reputation of the port was as vital as the cost of the passage. Though initially unable to offer suitable facilities, Antwerp as a port of embarkation gained strength in the years 1846-1847, when some 70 to 80 emigrant vessels left from the port. As well, hundreds of emigrants annually traveled via Antwerp to Great Britain for the Atlantic crossing. The stream of emigrants undoubtedly had the effect of increasing turnover among local Antwerp merchants. Local ship owners did not profit from the emigration business since the crossing was done almost exclusively in American vessels. Emigration was subject to political pressures in Europe as well; unrest in the whole of Europe interrupted the flow in1848 and 1849. From 1850 on the exodus to the New World started again.

The examples of profitable lines in other countries, especially successful routes like Le Havre-New York and Bremen-New York, stimulated a select group of Antwerp merchants and ship owners to try their luck again in the 1850s. They estimated that capital of BF 5,000,000 would be sufficient to set up a twice monthly service to New York using five vessels. They would contribute BF 1.5 million, provided that the Société Générale (the most

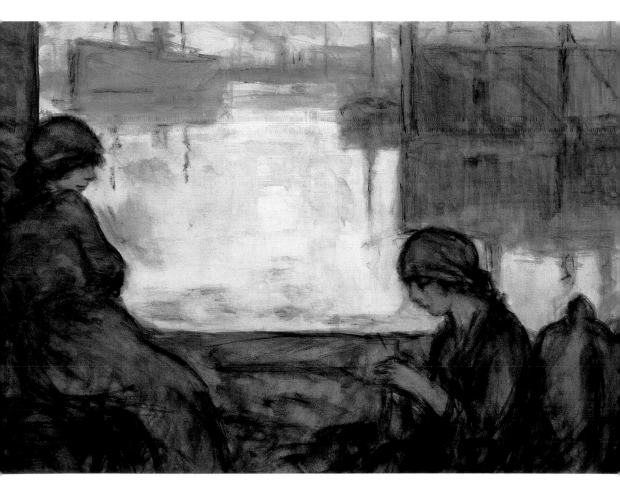

important Belgian industrial group) would take a BF 1 million holding and the state would guarantee an interest of 4 percent on the capital raised for ten years plus an annual subsidy. The Belgian government, clearly satisfied with this initiative, signed the agreement on May 29, 1853. In 1855 the Rothschild brothers purchased BF 500,000 worth of shares. This undertaking was a failure. The construction of the five vessels, two by van Vlissenhoven in Amsterdam and three by Cockerill in Antwerp, took much longer than planned. It was only at the end of 1855, more than a year late, that the first vessel, the Belgique, was ready. It sustained severe damage on its first crossing. Two more vessels were launched during 1856.

It was soon clear that costs had been greatly underestimated and revenue grossly overestimated. The fierce competition from long-established companies by far exceeded the financial resources of the Société Belge des Bateaux à Vapeur Transatlantiques. In 1858 the company was dissolved. As well, competition with European ports, and with Le Havre and Rotterdam, was too intense, causing Antwerp's share of emigrants to decrease after 1857, with only a few thousand on board each year. The outbreak of the American Civil War (1861-1865) made this situation permanent. Emigration via Antwerp remained at a low level during the 1860s.

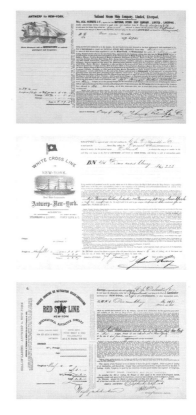

The New Spring (After 1863)

During the 1840s and 1850s a fierce campaign for free trade was successfully organized. The enthusiasm for this movement was felt worldwide. Traditional opponents sat down at the negotiation table, and old-age trade barriers were sometimes lifted in a matter of days. With the treaty of May 12, 1863, navigation on the river Scheldt was now again totally free. Belgium was now becoming a world power for coal, glass and metal production and Antwerp a center of industrial growth. The need for new port infrastructure was a race against time. After the American Civil War the number of vessels arriving from the U.S. was on the rise. European markets were flooded with cheap grain from the extensive cultivation now possible in the newly opened lands of the Midwest. The market for mineral fuels was also increasing. In 1880 coal and petroleum were the second most important category by volume; by 1910, these accounted for 21 percent of total imports. Among the lines sailing from Antwerp were the White Cross Line, the Pacific Steam Navigation Company, the Cork Steam Ship Companies, the Hamburg-Amerikanische-Packetfahrt-Aktien-Gesellschaft, the Dampschiff Rederei Hansa, the National Steam Ship Company Limited, the Norddeutscher Lloyd, the Inman Steam Ship Company Ltd., the Cunard Line and the Red Star Line.

Emigration from Europe once again became very important. The agrarian depression due to the import of cheap grain forced thousands to emigrate from their homes in western and eastern Europe. With the importing of grain and oil transport and the exporting of emigrants, the North American route regained its importance to the port of Antwerp from 1870 on. The Red Star Line became a major player. An agreement was signed on March 1, 1874, with the Belgian Government to organize two monthly sailings alternatively to Philadelphia and New York for an annual subsidy of BF 500,000. After some difficult years the new ship

Bill of lading, National Steam Ship Company, 1 May 1869
Antwerp, Van Mieghem Museum

Bill of lading, White Cross Line
7 June 1879
Antwerp, Van Mieghem Museum

Bill of lading, Red Star Line
26 September 1885
Antwerp, Van Mieghem Museum

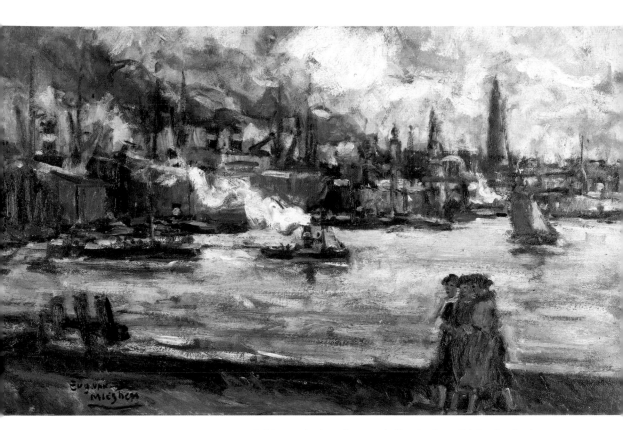

A view of Antwerp, 1927
oil on hardboard, 56 x 74 cm
Antwerp, APRA Insurance Company

overleaf:

(above), Antwerp, Avenue de Keyser
(by evening), ca. 1912
oil on panel, 20 x 29 cm
private collection

(below), Avenue de Keyser
postcard, ca. 1910
Antwerp, Van Mieghem Museum

owners (with mostly American capital) gained a solid footing in the
business of transport, mainly of emigrants to the United States.

The Aftermath of the First World War

After World War I Antwerp witnessed a period of unparalleled optimism.
The Allied victory imbued the country with self-confidence and Antwerp,
unscathed, became a symbol of hope for the future. The following years
saw the emergence of specialized cargo terminals. In 1921 the Great
Eastern Railway was granted permission to build a service building at
the Scheldt quays, which included a passenger station for its daily ferry
service to Harwich. The first expression of the industrial function of the
Antwerp port consisted of ship repairs in the dry docks, built by the city.
Shipbuilding and general industrial processing facilities were located
outside the port area and there were shipyards upstream alongside the
Scheldt in the industrial municipality of Hoboken. The automobile
manufacturers General Motors (1928) and Ford Motor Company (1930)
moved their operations to the port from other places in the city where
they had started on a much smaller scale (Ford since 1922 and General
Motors since 1924). Oil importing was a key activity from the start. After
all, Antwerp was the first European port to receive oil from the United
States. Originally, traffic had been concentrated in the America dock. Due
to lack of space, as well as for safety reasons, operations were gradually

25

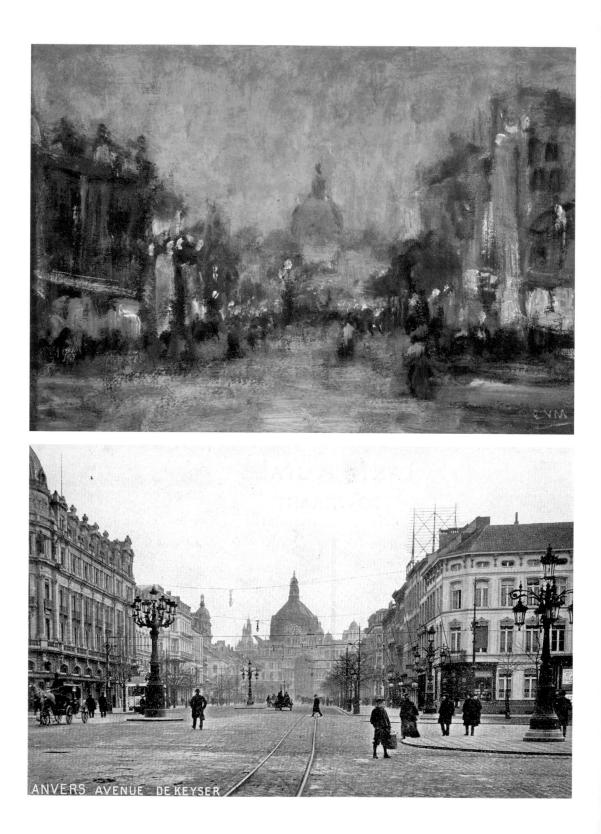

ANVERS AVENUE DE KEYSER

The Leysstraat (by night), ca. 1912
pastel, 52 x 46 cm
private collection

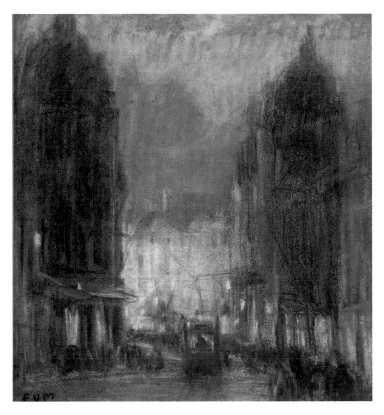

overleaf:
Ship in dry dock, ca. 1924
monotype, 50 x 44 cm
private collection

Antwerp, the Leysstraat
postcard, ca. 1912
Antwerp, Van Mieghem Museum

shifted to the southern part of the city. The American Petroleum Company
(forerunner of Esso Belgium) was already operational in 1903.
One of the leaders in metalworking was the Bell Manufacturing
Company, founded in 1882 by the Western Electric Co., the International
Bell Telephone Co. and a number of Antwerp dignitaries. The American
companies owned 75 percent of the share capital of this fast growing
telephone company.

It should be noted that Antwerp's port postwar development suffered
from a lack of space that was only remedied through the construction of
the Kanaal dock and especially the Kruisschans lock. One year after the
latter's inauguration in 1928, shipping reached a new record of 11,582
vessels and a total cargo of 26,066,683 tons—and turning Antwerp into
the third largest seaport on the continent, after Rotterdam and virtually
on par with Hamburg. The symbol of hope for the city and its port was
the construction in 1929/1931 of the first and for many years the tallest
skyscraper in western Europe, belonging to the Algemene Bankvereniging
(today KBC Bank). This building, which reaches 321.5 feet and has
24 floors, was ahead of its time in Europe. The year it was built, 1930,
was the same year the World Exhibition was organized in Antwerp.

The stormy development of the shipping industry in the 1920s naturally
declined in the early 1930s with the worldwide Great Depression that was
triggered by the stock market crash of October 1929. Protectionist markets
caused considerable difficulty for an export-oriented country like Belgium.

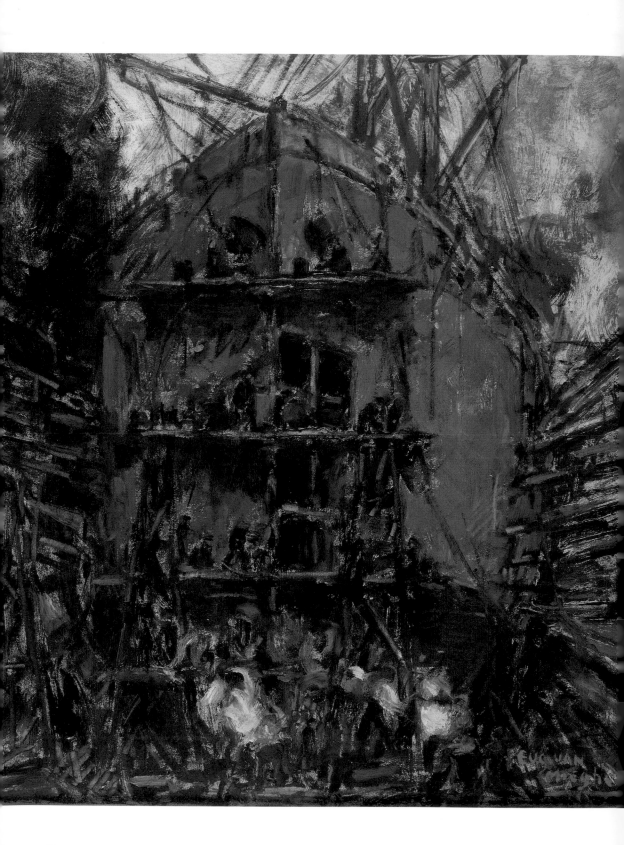

28

Shipment for America
postcard, ca. 1930
Antwerp, Van Mieghem Museum

overleaf:
Tribute to the port of Antwerp
ca. 1925, oil on canvas, 160 x 250 cm
Antwerp, HNN-PSA

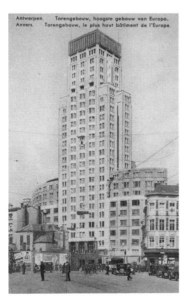

The Torengebouw, postcard, ca. 1931
Antwerp, Van Mieghem Museum

Belgium industry was in dire straits, and reached an all-time low in 1932 and 1933. Port traffic in Antwerp in 1932 dwindled to 9,407 vessels with 17,383,209 tons.

The Metamorphosis to a World Port

Also after the Second World War the port of Antwerp fell largely undamaged into Allied hands. In the following decades the port underwent impressive expansion. The efforts to restore the war damage were accompanied by serious improvements and renovation of the former equipment of the port. On May 2, 1951, work began on the construction of the Boudewijn Lock, which could accept the largest vessels of the day as well as simultaneously lock through four Liberty vessels. When it opened on October 22, 1955, it was the largest lock in Europe, with a length of 393.7 yards, a width of 49.21 yards and a water height above the lock sill of 15.86 yards.

Today, Antwerp and its port are undoubtedly the driving force behind the vibrant Flemish economy. Centrally located, the port ranks second in Europe and fourth in the world, providing easy access to almost the entire continent. In 2004, for the first time ever, the total volume of cargo handled in the port reached 150 million tons while the container volume rose above 6 million TEU. The port of Antwerp is the most important petrochemical center in Europe, with strong investment by industrial companies in the port area. On July 6, 2005 the Deurganck dock, the new tidal container dock on the left bank of the Scheldt was inaugurated. The Port Authority of Antwerp looks to the future with confidence. The deepening of the Scheldt, to provide for tide-independent navigation is now under construction and should secure the port's future.

Antwerp today is also the world center for diamonds. As early as the beginning of the 13th century, northern Europe maintained a continuous trade link with the East, mainly via Venice. One of Venice's most important trade partners was Bruges, a thriving port and one of the richest cities in Europe. Bruges became a center of the diamond trade and manufacturing. According to legend, the process of working one diamond with the aid of another, was invented by a native of Bruges, Lodewyk van Bercken. Towards the end of the 14th century, Bruges declined as a center of trade, due to various economic factors and to the silting up of the channel to its port. Antwerp took its place and became the most important city of the Low Countries. Before the 18th century, all diamonds came from India.

By the beginning of the 16th century, Antwerp had become the world center for the diamond trade and industry. Throughout its Golden Age, some 40 percent of the world's trade passed through the port of Antwerp. With the struggle for independence from Spain, the diamond trade and industry suffered. However, by 1900, Antwerp recovered. Discoveries in South Africa produced a bounty of rough stones, which restored Antwerp's status as the world's leading diamond center. By 1893 the world's first diamond exchange was established in Antwerp. After World War II, the Antwerp World Diamond Center boomed. Housed in a tightly secured area of two square miles, the Center comprises more than 1,500 diamond companies and four

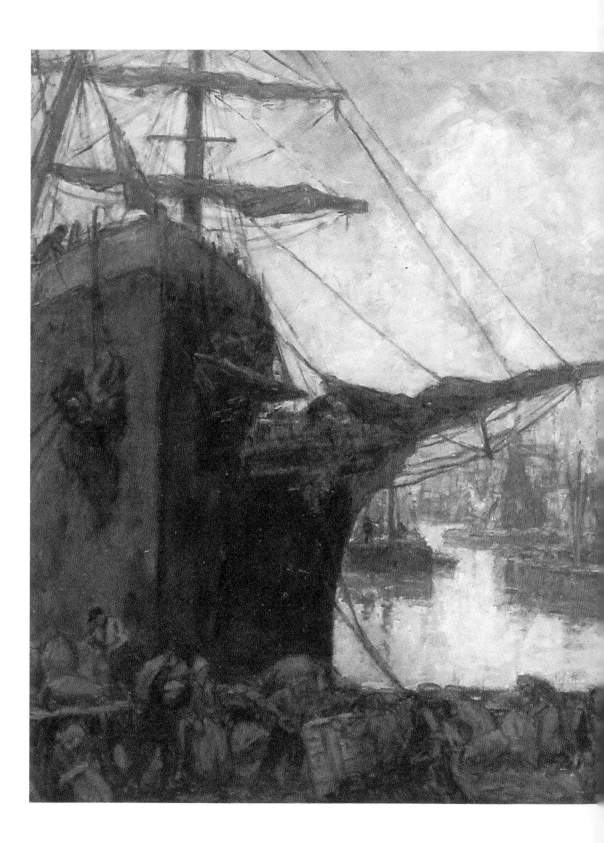

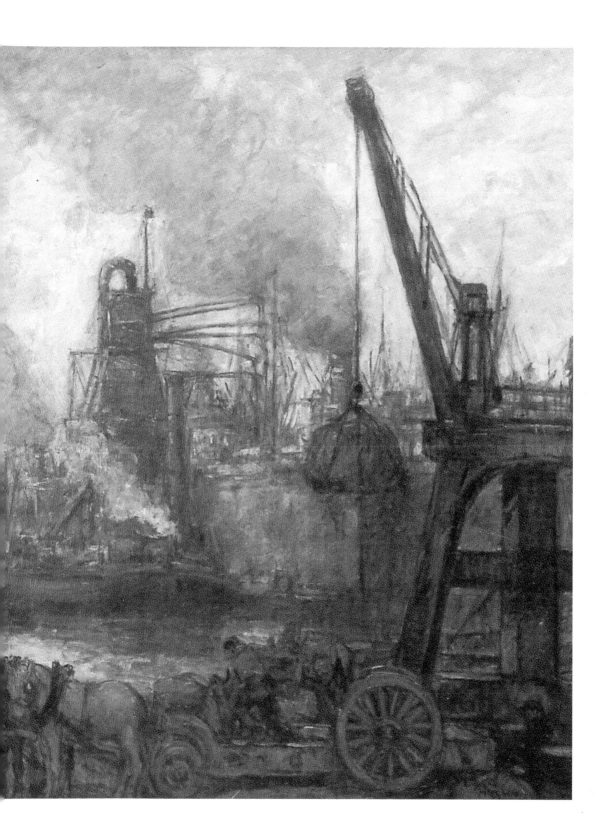

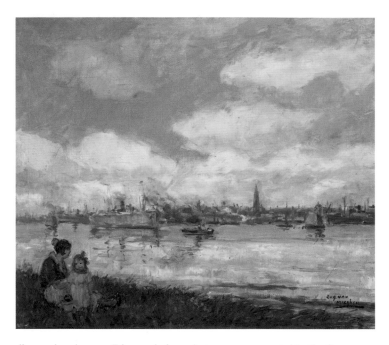

At the river Scheldt, ca. 1925
oil on panel, 50 x 70 cm
private collection

diamond exchanges. Diamonds from Antwerp are exported to the four
corners of the world. More than 50 percent of the world consumption of
rough, polished and industrial diamonds passes through Antwerp. Most
of the most important sight holders of the Diamond Trading Company
(former De Beers Consolidated Mines Ltd.) reside in Antwerp. The city also
enjoys international renown as a trade center for precious stones, such as
rubies, sapphires and emeralds. The diamond trade and production go hand
in hand in Antwerp. The quality label "cut in Antwerp" testifies to the
superb skill of the city's diamond workers.

The city has also become one of Europe's trendsetters in the fashion world.
Belgian designers with roots in Antwerp have emerged internationally.
The driving force behind the Antwerp fashion scene continues to be the
Fashion Department of the Royal Academy of Fine Arts.

Antwerp is today the second largest city in Belgium, behind Brussels,
and the largest in the now autonomous region of Flanders. Flanders itself is
an open, creative and versatile society that straddles the historic border area
between the Germanic and Romance cultures of Europe. As the northern,
Dutch-speaking part of Belgium, Flanders has, like Antwerp, undergone
major reforms in the last decades that have made it stronger and more
distinct in its politics and its identity.

right:
Self-portrait, 1894
oil on panel, 18 x 12 cm
private collection

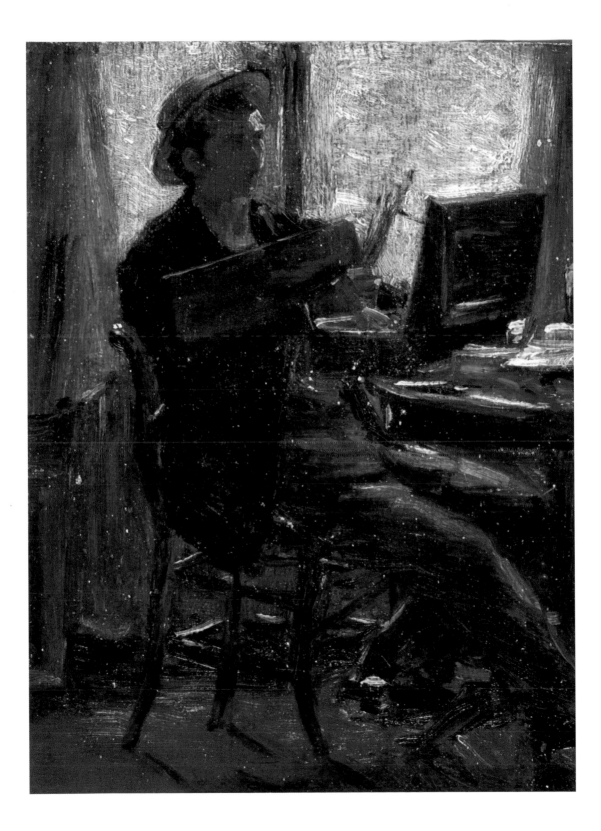

2. Eugeen Van Mieghem (1875-1930)
"An Artist of the People"

Early years (1875-1901)

Eugeen Van Mieghem was born on October 1, 1875, in the inn called
In Het Hert (In the Heart) that his parents owned on the Van Meteren
Quay of Antwerp. Van Mieghem spent his childhood playing on the banks
of the river Scheldt, in the center of the old port's activity. From his vantage
point at the inn he could see boats mooring at the dock and exotic goods
being unloaded. From behind the corner of the pub he observed the colorful
visitors: shipmasters, sailors, stevedores, dockworkers and seamstresses.

The long rows of emigrants with strange national costumes that passed the
inn intrigued the boy. Van Mieghem's earliest impressions of his distinctive
childhood environment made a deep impact that would later reveal itself in
his mature art.

In June 1877 the Antwerp City Council began the building of stone
quay walls. When the construction neared the Van Meteren Quay,
Van Mieghem's father decided to move north. He sold the old inn and built
a new one on Montevideo Street, on the Eilandje (The Little Island).

The tramp, 1895
pastel, 23 x 27 cm
private collection

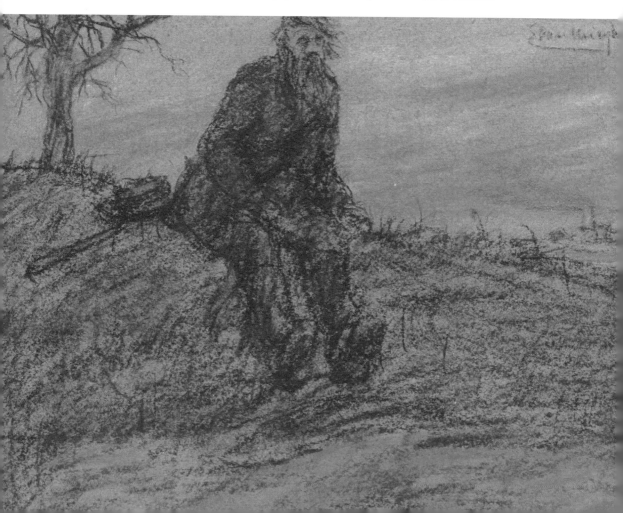

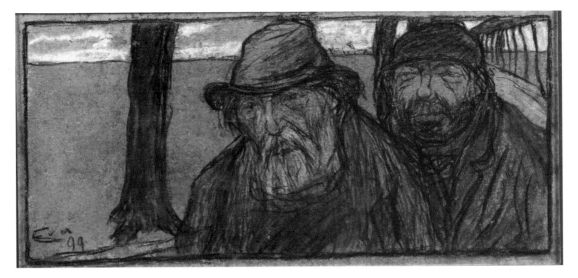

Two tramps, 1899
pastel, 13.4 x 28.4 cm
private collection

The new inn was directly across from the warehouses of the Red Star Line shipping company.

At school the young Eugeen already showed interest in and talent for drawing. One of his teachers was Pol de Mont (1857-1931), who came to play an important role in the struggle for Flemish cultural independence. In 1891 the young Van Mieghem registered for the evening classes at the Antwerp Academy. At the time, the citizens of Antwerp nicknamed their city the "Art Metropolis," because of its role as a center of the arts, as opposed to Brussels, the center of political power. Until well into the twentieth century, Antwerp was considered a stronghold of artistic conservatism due to the lingering effect of a local painting tradition of emulating the historical genre of Henri Leys (1815-1869). Indeed, Romanticism was alive and well in Antwerp. One of its leading exponents, Nicaise De Keyser (1813-1887), remained the head of the Royal Academy of Fine Arts until 1879 and was succeeded by Charles Verlat (1824-1890). Despite Verlat's initial embrace of Realism, as defended by Gustave Courbet, he soon became a figurehead for the conservatives. At the same time, he became the object of derision among the young painters of the 1880s who were trying to break out of the limitations of what they saw as an antiquated concept of art. The influence of the Academy was considered by many, especially by the Modernist movement in Brussels, as a source of the stagnation in Antwerp's art scene.

On May 29, 1892, Henry Van de Velde and his artistic society, *L'Association pour l'Art*, organized their first exhibition in the old Antwerp Museum on Venus Street at the back of the Academy. Their first show exhibited posters from Chéret, as well as work by Vincent Van Gogh, Georges Seurat, Walter Crane, Camille Pissarro, Paul Signac and de Toulouse-Lautrec. It is certain that Van Mieghem, who was a full-time student at the Antwerp Academy that year, visited this exhibition. A year later, on May 7, 1893, *L'Association pour l'Art* issued invitations for their second and last salon. This time they exhibited works by Theo van Rysselberghe, de Toulouse-Lautrec, Paul Signac, Maurice Denis, Maximilien Luce and Constantin Meunier.

From Parisian art magazines the young Eugeen Van Mieghem was learning about the works of Théophile-Alexandre Steinlen. Steinlen (1859-1923) was born in Switzerland, where he studied art at Lausanne and later became active as a textile designer across the French border in Mulhouse. In 1882 he arrived in Paris, where he worked as an illustrator for the journals *Le Mirliton, L'Assiette au Beurre, Le Chat Noir,* and *Gil Blas,* for which he produced over four hundred lithographs. As an artist he was much more than a commercial success, demonstrating great sensitivity toward his subject matter. Besides illustrating advertisements for a variety of products, Steinlen was famous for his posters of cabaret and music hall performers. However, his later work for the journals, unlike that of Toulouse-Lautrec became increasingly satirical and more of a social commentary. Steinlen, too, often drew genre scenes of the working class, capturing day-to-day life in Paris with a simple, endearing style. His influence is clearly seen in the works of Eugeen Van Mieghem—as it was in the young Pablo Picasso, Ernst Barlach, Käthe Kollwitz and Kees van Dongen.

By continuing to draw port views and portraits of the people around him, Van Mieghem was, before long, at odds with his conservative teachers, who found his style too free and spontaneous. They looked askance at his subject matter, the working class and dockland figures he painted, and his interest in contemporary art. In 1896 Van Mieghem's teacher Eugeen Siberdt dismissed him from the Academy—just as he had done to another former pupil, Vincent Van Gogh.

Van Mieghem took a job in the port, but his artistic resolve was undiminished. He developed his artistic talents fully during the next few years, which were highly productive for him. While the Antwerp port world remained his chief source of inspiration, his work - both the paintings and the pastel drawings - also embraces a characteristic personal style that features the use of delicate tones. Although the influence of such artists as Van Gogh, Seurat, Daumier and Toulouse-Lautrec is evident in his work,

The blind man, 1899
black and red chalk, 13 x 20 cm
private collection

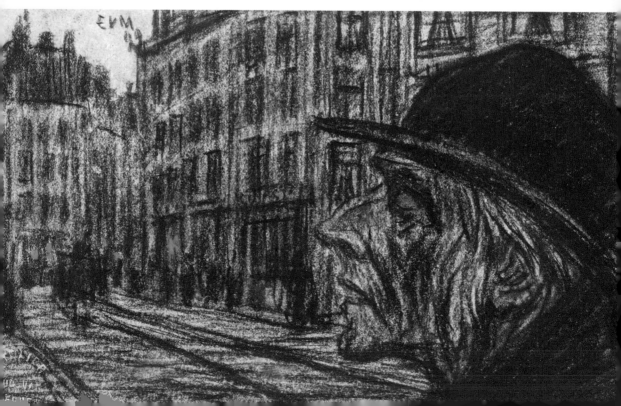

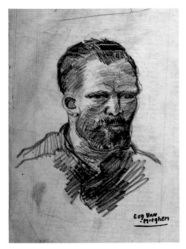

Vincent Van Gogh, ca. 1924
pencil, 21.6 x 14.2 cm
private collection

Antwerp, the Leysstraat
postcard, ca. 1900
Antwerp, Van Mieghem Museum

Van Mieghem's art resists categorization into any particular school or movement. He was an individualist who rarely traveled abroad.

Around 1898 Van Mieghem met his future wife, Augustine Pautre, a Brussels girl studying at the Academy in Antwerp. That same year he exhibited for the first time with the Antwerp group *De Scalden,* an art society that paid significant homage to the applied arts and the English Arts and Crafts movement as practiced by William Morris (1834-1896) and Walter Crane (1845-1915). By 1899 Van Mieghem's drawings had already achieved a remarkable expression and maturity. He was eager to be part of the progressive political and cultural movements of the Antwerp of the early 1900s. He became involved in the anarchist group *De Kapel* (the Chapel), which gave him a strong sense of social engagement that never left him. *De Kapel* was an anarchist literary association founded by the Antwerp businessman, art dealer and collector François Franck in 1899. The 17th-century chapel Lantschot, located in a working-class area, became the meeting place and a unique center of Antwerp cultural life. Exhibitions, lectures and music evenings were organized for an often agitated and enthusiastic public open to various ideologies - socialist, liberal, anarchist and Flemish fundamentalist - and to people from all walks of life, ranging from the higher and middle classes to laborers, dockers and craftsmen. Writers (such as Frederik van Eeden, Stijn Streuvels, Emile Verhaeren, Camille Lemonnier, Georges Eekhoud and Willem Elsschot), politicians (including Emile Vandervelde, Edmond Picard, August Vermeylen, Louis Franck) and intellectuals (e.g., Octave Maus and Elisée Reclus) spoke before a fascinated audience. *De Kapel* became the breeding ground for all the major new initiatives of cultural importance in Antwerp in the twentieth century.

The author Ary Delen described the space. "On the site of the former altar hung Steinlen's poster of "L'Aurore", on which a woman stretches her arms out in longing to the flaming dawn of the future. Underneath was a long table with magazines like "Van Nu en Straks", "La Société Nouvelle" and "Les Temps Nouveaux".
Van Mieghem and his friends were regular visitors. Because Van Mieghem always remained in the background, one of his friends, Edmond Van Offel, described him as: "...the sharp, small thin boy, the shoulders somewhat shrugged, looking around restlessly with his sharp tongue, grinning, putting everybody in his place in a sarcastic way. One often forgave him his slander because of the humor that transpired from it. Because he was funny, the man..."
What they stood for can be described as a bohemian anarchism. Another friend, Lode Baekelmans wrote: "...It was a time in which we strived for brotherhood in the way Jacques Mesnil had demonstrated to us in "Van Nu en Straks" (From Now and Later). A free community where everyone lovingly fulfilled their self-appointed task. We read Pierre Kropotkine, Jean Grave, Max Stirner, "Le père Peinard" and "Les Temps Nouveaux", Elisée Reclus, Faure and a lot more..."
Baekelmans and his friend Resseler became editors of the *Onze Vlagge, Jong-Vlaamsch Strijdblad* (Our Flag, Young Flemish Militant Magazine). Other collaborators were Emmanuel de Bom, Georges Eekhoud and Jacques Mesnil. In one early issue Maurits Nykerk, an artist and friend of Van Mieghem, published the article *"Hulde aan Emile Zola: een semiet over de zaak Dreyfus"* (In honor of Emile Zola: a Semite about the Dreyfus case).

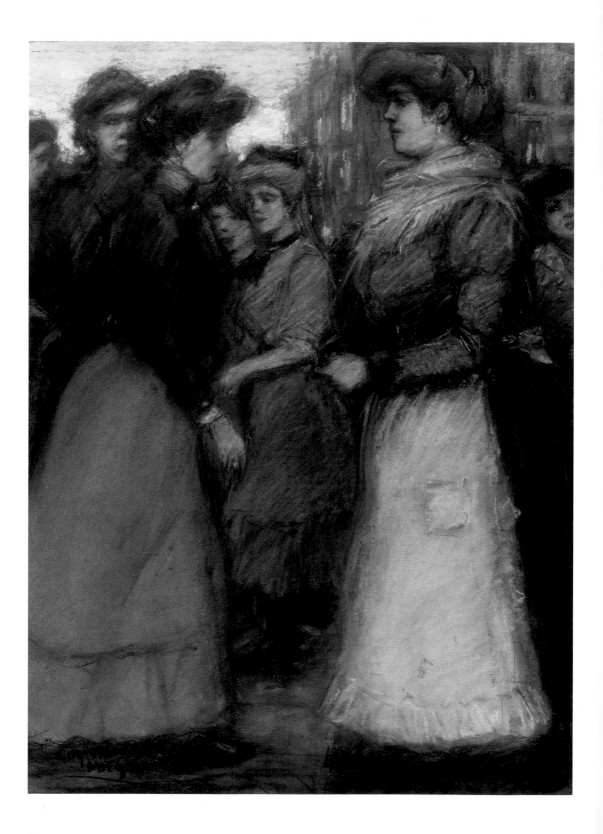

The new social idealism struck a chord with Van Mieghem, causing him to develop a set of moral principles he never renounced. He wanted to be the artist of the people in this fast-growing world port. Indeed, Antwerp was rapidly becoming a cosmopolitan city; in 1900, more than 10 percent of its population was of foreign origin. In 1900 Van Mieghem exhibited again with the group *De Scalden* in the Old Antwerp Museum. Writing in *De Vlaamse School* (The Flemish School), Pol de Mont had much to say about the *"Nieuw kunstleven in Antwerpen"* (New art life in Antwerp). While Brussels had surpassed Antwerp over the past decade because its central location and wealth attracted many talented artists, de Mont described the positive activism of the Antwerp artists: "...Nowadays there finally is a core of "youngsters", if not yet formed, it is forming. A core of "youngsters" averse to all the idle fashionable things and studio heritage, want to give an art that is the nature and sincere expression of their personality and their race..."

On March 1, 1901, the eighth salon of *La Libre Esthétique* opened in Brussels. For the show Van Mieghem had on exhibit ten drawings and pastels, next to French Impressionists such as Cézanne, Cross, Sérusier, Denis, Monet, Pissarro, Renoir, Vuillard and the Swiss artist Ferdinand Hodler. It is likely that Van Mieghem was invited on the recommendation of Henry Van de Velde, who had relocated to Brussels. Van de Velde knew Van Mieghem's work because they both participated at the salon of *De Scalden* of 1900, where Van de Velde had given a lecture. Writing again in his magazine *De Vlaamse School,* Pol de Mont stated: "...What I was most pleased about is the support Van Mieghem got. His eight views into the poor man's life in the Antwerp port district made me hope that -finally- once, even if it is one single person from Antwerp, born in Antwerp, would dare to depict his city, with all its color, rumor and characteristic beauty... Will he? We desperately long for it..."

The Married Years (1902-1905)

On January 28, 1902, Van Mieghem married Augustine Pautre. Four days after the marriage he made two exquisite little portraits of his lovely wife. The young couple lived with Van Mieghem's mother in the back house of the inn (the artist's father had died in 1899).

Pautre was the subject of some rare Impressionist works done between 1900 and 1903. Unfortunately, Van Mieghem never exhibited these charming pictures, which he gave to his wife or a friend. On the 24th and 25th of August he made a sketchbook from fragments of catalogues from an exhibition of his work in the *Eenigen* ("A Few") salon of April 1902. Here he made sublime sketches of his environment and drawings of friends, family and his pregnant wife Augustine. On November 11, 1902, the artist became the father of a son who would bear his name.

The third exhibition of the *Eenigen* group in 1903 took place in the Koninklijk Kunstverbond (The Royal Art Society). Pol de Mont wrote in the English art magazine *The Studio:* "...This exhibition tends to prove once more that a renovating movement is pending at Antwerp, and we may expect the happiest results there from..."

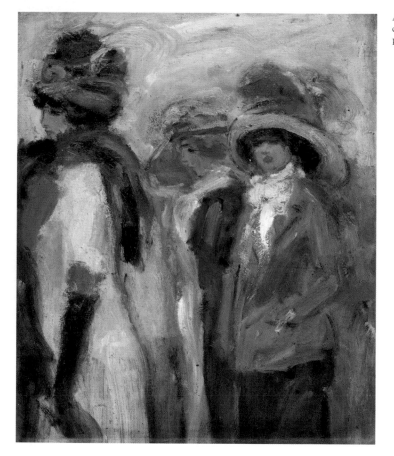

Augustine amongst fashionable ladies
ca. 1902, oil on panel, 34 x 29 cm
private collection

In January 1904 Lenore van der Veer wrote the following article, *"An Artist
of the People,"* for the London magazine *Pall Mall:* "In the old harbor town
of Antwerp one comes upon all sorts of artists, for art is in the very air; but
those who most claim one's attention seem always to belong to that set of
men who live on ramshackle top floors in the old quarter of the town, their
windows overlooking antiquated Spanish tiled roofs, the brilliance of the
red toned into a wealth of color by the passing of the years. Beyond lies
their beloved Scheldt, mist-laden, and flecked with ships in harbor and
others fading from view into the distant grey of the sea. They know little
beyond their art and their Antwerp, these painter-fellows, and are as
indifferent to time and to the great things of the world outside as though
they were back in the Middle Ages.
They may have to make ends meet on eight or ten francs a week, and to
live a more pinched and narrow existence than the workpeople whom
they paint at their toil; but nothing could tempt them to change their
environment. Many of them were born in just such surroundings. One need
not come from artistic lineage to be born artist in Belgium, and the son of
a laborer is just as likely to find himself the artist of the future, as are the
more happily environed children of distinguished parents. In Antwerp
artistic gifts seem to be embodied in microbes, and the most unlikely people
become inoculated.
Every boy in Antwerp goes to the Academy art classes after school hours,

right:
Augustine Pautre, 2 February 1902
pastel and black chalk, 19.1 x 13.2 cm
Antwerp, Municipal Print Room

40

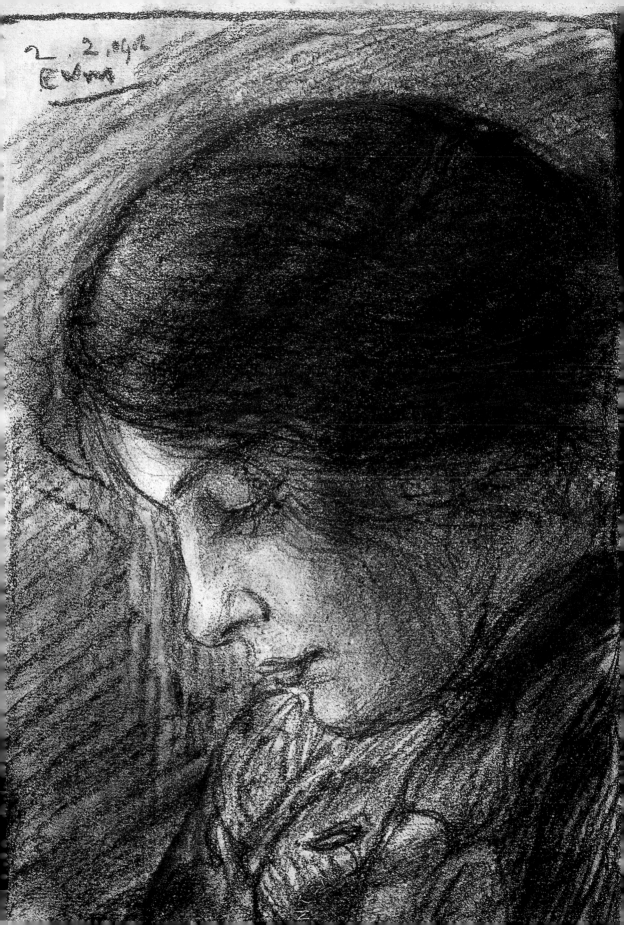

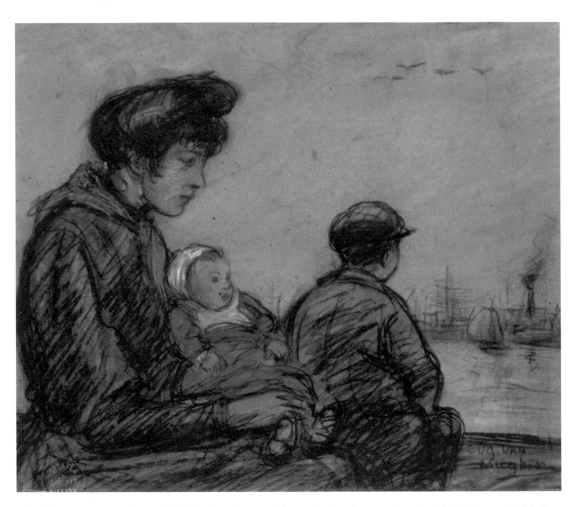

Augustine with little Eugeen at the Scheldt
1903, pastel, 25 x 30 cm
private collection

where he potters around at make believe drawings, until he gradually takes on the spirit of the older workers, and starts in earnest to learn something for himself. Many of these youngsters turn out to be fairly good at their work, and occasionally one among them develops the most intense passion for art, and everything in his life becomes secondary to his studies - even his small personal comforts, if necessary; while the other members of the family, all plodding workpeople, yield cheerfully to his demands, and throw in their lot, in their limited way, with the gods who are supposed to help and foster budding genius. Born in the neighborhood of the Antwerp docks, Eugene Van Mieghem, the subject of this sketch, only followed the bent of his earliest playtime when he took to depicting the "Dockers"; for he played on the docks as a child, and later, as he grew into a strong lad, he worked at loading and unloading the big ships' cargoes, and helped in the general labor of the busy port.

In the evenings he attended the free art classes in the Antwerp Academy, but it was due to his training during his working-days that the boy grew to have so close an observation for the simple details of his working world, which first gave him so complete a grasp of the material upon which he had since built up his art.

right:
Augustine daydreaming, ca. 1904
black chalk, 12.6 x 17.3 cm
Antwerp, Municipal Print Room

He passed uneventfully through the various drawing classes in the Academy, until he came to the life class, where for the first time in his life he was thrown amongst serious-minded men, both of his own and other countries, and gradually his eyes opened to the fact that he too loved art the same as they did, and that somehow, almost unknown to himself, he could give expression to this feeling in work which was fast becoming a passion. Then followed the old story of the art student with personal convictions and originality of expression, ending in revolt against the narrowness of academic convention, and quitting of the schools in sheer desperation to worry out his technique for himself. After leaving the schools, he continued for a time to work at the docks, but always with a pad and pencil with which to jot down something striking to his artistic sense in the ever-changing life of the port. By-and-by he gave up his work, and set-to making more pretentious studies, which he hoped would afford him a source of income sufficient for his simple needs; but he soon found that the selling of pictures in Antwerp had long since become something of a myth, and he showed his good sense and practical knowledge of business matters by renting a small house close by the docks, which he simply fitted up as a café, marrying a pretty Belgian lassie, and installing her, together with his mother, as a hostess in what was soon quite the most popular place of its kind in Antwerp harbor.

Having so cleverly arranged for the business end of his affairs, the artist gave himself over heart and soul to his drawings, spending his days and evenings on the docks, making studies of his old fellow-workers, for there is no cessation of bustling work night or day in a busy harbor; and many of

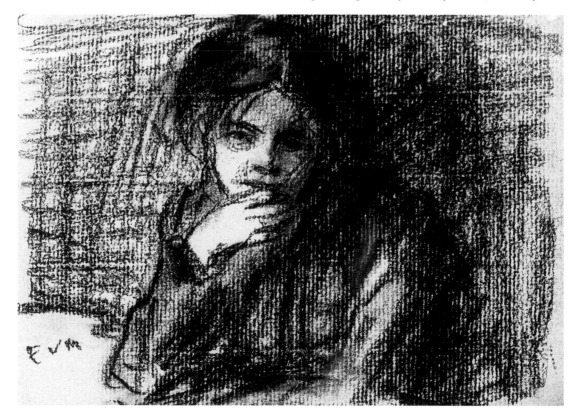

his best studies are of brawny Flemish workmen, powerful as their towering horses, running on narrow planks up the vessel's side, carrying enormous loads on their backs, their figures thrown into half-light by flickering torches set up here and there amongst the medley of cargoes lining the pier. No other phase of life but that of the workpeople to whom he belonged appeals to him; and if he is not at work sketching on the docks, he is drawing some grimy street near by his work-place - narrow, smoky, uninhabitable almost, but in the old tumbledown houses and dead trees running down to the ramparts the artist recognises the most wonderful greys and ochres and reds that ever set off a picturesque humanity. It is here he goes in search of his types apart from the laborers - the men and women who never work, but live like dogs, part of the time on the water, the rest on the streets, hiding away among the cargoes of the docks at night-time, and slinking off in the early dawn to search for scraps of food in the rubbish-heaps of the streets.

Augustine as a model, 1904
pastel, 28.2 x 18.1 cm
private collection

In the street-ruffian and the jack-tar ashore and the old organ-grinder of the alleys, the artist finds the types for his pencil, and in the pathetic group of emigrants, watching, with something of past happiness and lost hope in their eyes, the on-coming ship which is to bear them to a strange land. The artist's work is good because it is synthetic without spoiling the individual character of each of his several extremes of types, and because of its sincerity. There is nothing of the made-up stuff about it, produced in a "chic" studio with Eastern carpets: it is downright realism, snatched from the life of the streets by one who makes the streets his work-place; and this is what gives it that spontaneity and freshness of the actual. Nor does the artist see the life of his people through the eye either of a Socialist or of a Salvation Army fighter, nor as the artist who, after a good luncheon and comfortable smoke, goes out in a flannel shirt and old trousers to paint his friends, the dockers. Van Mieghem paints them simply because it lies in his nature to do so, without the slightest affection; and one feels him to be quite honest, both in the choice of subjects and their realisation; and one likes him for the originality of his vision, and for the acute perception and very personal view he has of his themes, as well for the fine, thoroughly painterlike qualities of his execution.

In a way he has already done for Antwerp what Steinlen has done for Paris, only the Belgian town does not offer such returns by way of recognition and substantial approbation to its workers as does the French capital; and were he dependent on his art for his livelihood, I fear there would be less of the good things of life for his little family than the merry café now affords. He is scarcely known beyond a small coterie of Antwerp artists, even in his own country, and I am very sure that no one in England has before heard of his work; but little does the artist care. This is one of the peculiar characteristics of the Antwerp artist: his work may be ever so good and distinctive, and he may plod along from youth to old age without any particular recognition - he will never bother himself over it; but so long as he can manage to keep soul and body together, and find the few francs for working materials, he goes on content in the life of his work, recking not a sou what the world thinks or does not think of him. Nevertheless, Van Mieghem has ambitions for the future. He realises that in this particular field he stands alone, and the fact that he is depicting the phases of life to which he and his people for generations were born deepens his sympathy and quickens his aspirations. During the few years he has given entirely to his art he has made thousands of character-studies, showing his people in their own world as he knows it: the endless drudgery, the pinch of poverty,

the moments of dull despair, the primitive pleasures with which they seek to drive away care, the brutality of some, the silent heroism of others - all these and more, he has shown, and it is to these studies that he hopes to owe his personal triumph in the more ambitious pictures already taking form in his brain. Not that he is ambitious to be known to the world as a great painter of the labouring classes, for he cares little to be known at all; but in his nature, which is so strange a mixture of the working man and the refined lover of the beautiful, there has come, little by little as his capacity for art expression developed, the desire to let the world see, in all its pathetic and terrible realism, just what it means to be born of the people..."

In July 1904, Van Mieghem went to Amsterdam to participate in the exhibition to honor the Dutch socialist and anarchist leader Domela Nieuwenhuis. Ferdinand Domela Nieuwenhuis (1846-1919) was the Netherlands' first prominent socialist. He was a Lutheran preacher who became the first elected socialist in the Dutch parliament. After taking his studies in theology, Nieuwenhuis became an evangelical Lutheran preacher and served in various Dutch towns. During this time he gradually lost his faith and came into contact with the social issues of the time. He stopped preaching in 1879, becoming active in various socialist activities. In 1887 Nieuwenhuis was sentenced to one year in prison for insulting royalty in an article. In 1888 he was elected into the Tweede Kamer, one of the two

Augustine sick in bed, 1905
black and brown chalk, 13 x 20.4 cm
private collection

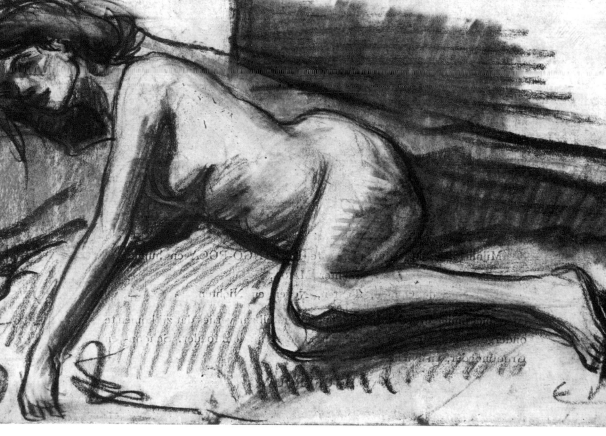

45

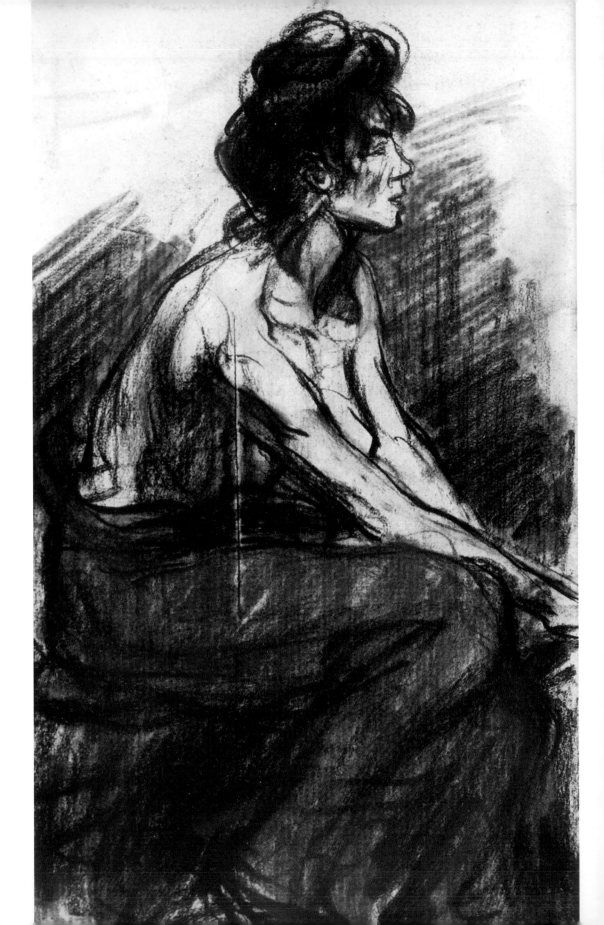

François Franck
photograph, ca. 1902
Antwerp, Van Mieghem Museum

chambers that make up the Dutch parliament and served until 1891, when he became disaffected and frustrated by parliamentary procedure. From then on Nieuwenhuis moved more and more toward anarchist beliefs and kept publishing and fighting for social anarchy, particularly justice for workers. In the "*Domela Nieuwenhuis*" memorial album, van Mieghem's drawing, "*The lonely man*," falls amid work by artists such as Walter Crane, Kees van Dongen, Maximilien Luce and Jan Toorop. This album also contains letters of sympathy by Baekelmans, Eekhoud, Kropotkine, Reclus and Verhaeren. During his stay, Van Mieghem visited the museums in Amsterdam and admired the work of Rembrandt, Vermeer, Jozef Israëls and George Hendrik Breitner.

Van Mieghem returned home, and by November 1904, was in dire financial straits. To raise cash, his wife Augustine posed nude for her husband and a group of artists. A few months later Van Mieghem drew his ailing wife on the back of mourning cards, bills of lading and port telegrams. All of the approximately 15 known drawings of this sickly young woman that survive demonstrate an astonishing power and expression. It was as if the artist could only cope with the devastation by continuing to draw his beloved as he had always done. Art critics today compare these drawings to similar works by Käthe Kollwitz and Ferdinand Hodler. Augustine died of tuberculosis on March 12, 1905, at the tender age of 24. Demoralized and desperate, Van Mieghem did not show his work at all in the period between September 1905 and March 1910.

The Quiet Years (1906-1909)

Emigrant walking, ca. 1902
black chalk, 21.8 x 12.6 cm
private collection

left:
Augustine sick, 1905
colored chalk, 20.8 x 12.8 cm
private collection

On February 5, 1905, in restaurant Le Paon Royal (next to the Antwerp Zoo), François and Louis Franck held the preliminary meeting to persuade Antwerp's wealthiest business people to support the founding of the cultural initiative known as *Kunst van Heden* (Art of Today). On March 1, the real inaugural meeting took place at the home of Louis Franck. Those present included his brothers François and Charles, Carlito Grisar (the later president), Georges Serigiers, Emmanuel de Bom, Pol de Mont and the Antwerp artists Baseleer, Hageman, Mertens and Vaes (all of the group *Eenigen*). Because of Augustine's grave illness, Van Mieghem, at the time one of the most promising young artists of the Antwerp school and co-founder of *Eenigen* was absent.

In April *Kunst van Heden* opened his first exhibition, "*Leys and De Braekeleer*," in the new Antwerp Museum. François Franck, whose talent for marrying salesmanship with patronage made him a mainstay of Antwerp's cultural life for decades, was clever enough to kick off the new society with a guaranteed success, given the conservative taste of the Antwerp public. On July 22, *Kunst van Heden* opened its first modern salon in the old museum in the Venus Street with works by Belgian artists Meunier, Baseleer, Claus, Ensor, Frédéric, Hageman, Laermans, Mertens, Minne, Morren, Oleffe, Van Rysselberghe, Smits, Vaes and Van Mieghem. The foreign artists represented included Breitner and Verster (The Netherlands), Besnard and Cottet (France), Zuloaga (Spain) and von Hofmann, Rohlfs, Thoma and Zügel (Germany). Eugeen Van Mieghem exhibited 23 pieces; of these, his painting "*Snow*" was acquired by Octave Maus who donated it

in 1906 to the Museum of Elsene (Brussels). After this first modern salon of *Kunst van Heden* Van Mieghem shattered and grief-stricken, would not exhibit for five long years.

Antwerp suffered one of its longest harbor strikes in 1907. The strike began on August 5th, and reached a climax on September 3rd and 4th, with riots and arson in the port. The Van Mieghem family inn suffered from the strike, sending the artist into another emotional and psychological downturn. In a sketchbook of 1907 is a self-portrait of a tormented and depressed artist. Only on September 26th, after much hardship and violence,

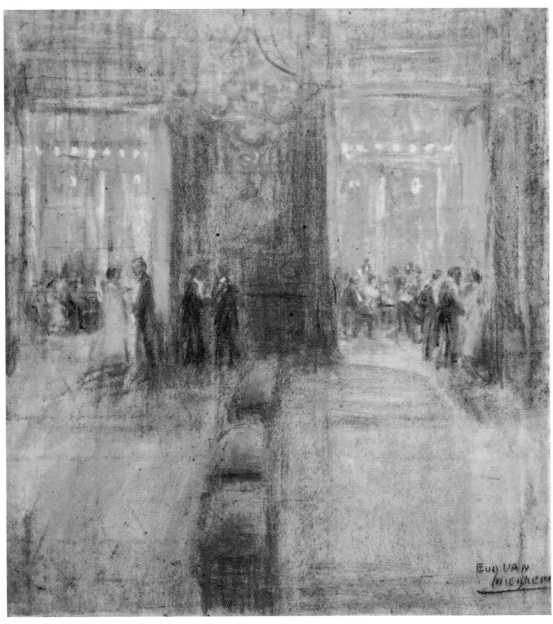

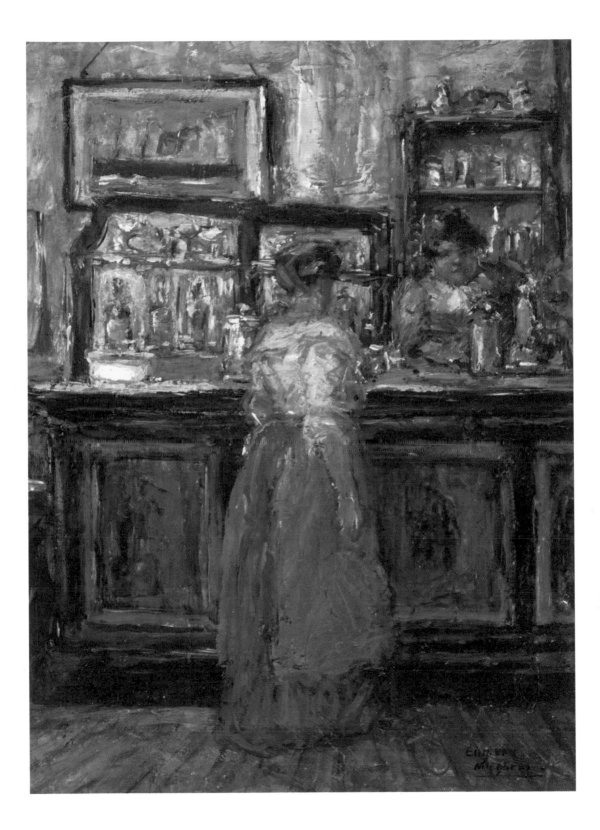

the strike finally came to an end. For a long time afterward, Van Mieghem was known to draw with soap on the mirrors of his mother's inn.

The Years of Recognition (1910-1913)

Finally, after virtually disappearing for nearly five years, Van Mieghem returned to the art world in March of 1910, when he exhibited seven paintings in the annual salon of *Kunst van Heden*. Two years later, at the age of 37, he mounted his first solo exhibition at the Antwerp Koninklijk Kunstverbond (Royal Society of Art). The public and the critical response was enthusiastic. As the art critic Ary Delen wrote: " ...Van Mieghem is a special character. His sharp observation, his superior view on people and things around him, are his means to create an original art, that does have its affinities, but is very much his own and appeals to us because of the special sense of color, the exact capacity of depicting the often harsh reality... The work of Van Mieghem has a special place. In this first exhibition he has showed himself as one of our most interesting artists,

right:
In a tavern, 1913
mixed medium, 46 x 34 cm
private collection

Carnival, 1912
pastel, 47 x 65 cm
private collection

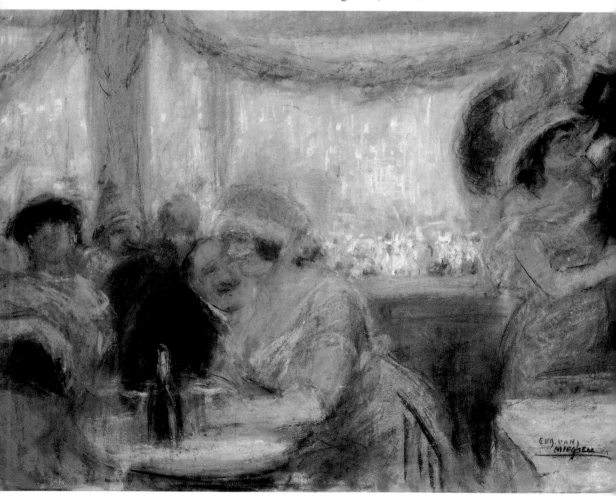

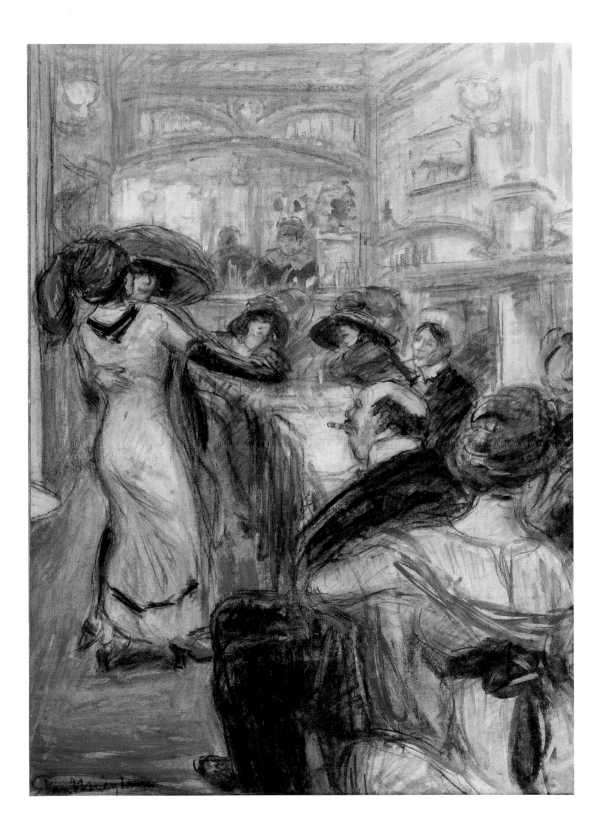

of whose multiple and personal talent we may expect a lot more..."
The newspaper *La Métropole* wrote: " ...here we see a painter who is not
a beginner, who has worked for fifteen years already and has remained
virtually unknown to the general public. There are however few others in
Antwerp who have a strong a personality as he has. He is deeply absorbed
by his art - you can feel that in his small sketches, his drawings, he mainly
works for the pleasure of the work and not for the expression of his
feelings, that comes second to him. He is above all a passionate observer
of life, the intense life of the big city, the city of the masses, the busy city,
with its anthill of people and workers and loafers... Above all we recognize
the personal temperament of the artist, the temperament of a searcher,
a curious man who is not put off by a bit of naughtiness and who himself
has a great admiration for all that happens around us... and we hope that
this exhibition will give Mr. Van Mieghem for good the place amongst our
painters that he deserves."

The bedroom, 1914
oil on panel, 25 x 30 cm
private collection

The exhibit consisted of 39 paintings and 52 pastels, watercolors and
drawings, and featured works shown for the first time, particularly
Van Mieghem's scenes of and around the famous café Hulstkamp at the
de Keyserlei. The Hulstkamp was a meeting place for artists, including
foreigners like the Italian sculptor Rembrandt Bugatti (1885-1916), who
stayed in the nearby hotel Weber. Bugatti unfortunately never took part in
a salon of *Kunst van Heden* but in 1910 did mount an exhibition in the
marble hall of the Antwerp Zoo.

In Van Mieghem's work depicting the carefree Antwerp middle class and
its night life one can sometimes see similarities with the art of Jean-Louis
Forain. Even when done in a lighter, sometimes humorous vein,
Van Mieghem's work reflects the artist's personality. Known Antwerp
collectors began buying his work. In March 1914, five works of his hand
were shown in an exhibition of Belgian art organized at the Pulchri Studio
in The Hague (the Netherlands). He also participated in the annual
exhibition of *Kunst van Heden*, with 29 paintings in the modern section.
The retrospective section featured work by Jakob Smits, Rik Wouters
and Vincent Van Gogh (96 pieces!). Van Mieghem was surrounded and
impressed with the now-world famous works of Van Gogh, such as
"*The Irises*" and "*The Bedroom*" in Arles. That year, Van Mieghem was
one of a distinguished group (that included Rik Wouters) to become
member artists of *Kunst van Heden*.

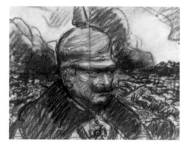

The emperor, 1916
black and brown chalk, 21 x 24 cm
private collection

Van Mieghem's rising popularity among collectors was abruptly broken by
fate: on August 4, 1914, the German army attacked Belgium. In the first
week of October German troops bombed Antwerp. The Van Mieghem
family joined the majority of population who fled their beloved home city
of Antwerp.

The War Years (1914-1918)

Antwerp was bombed on October 7th, 8th and 9th of 1914. The German
army destroyed the fortresses that surrounded the city and carried out night
bombardments using zeppelins. The civilian population, including the
Van Mieghem family, fled the city in panic. There is a sad irony to the fact

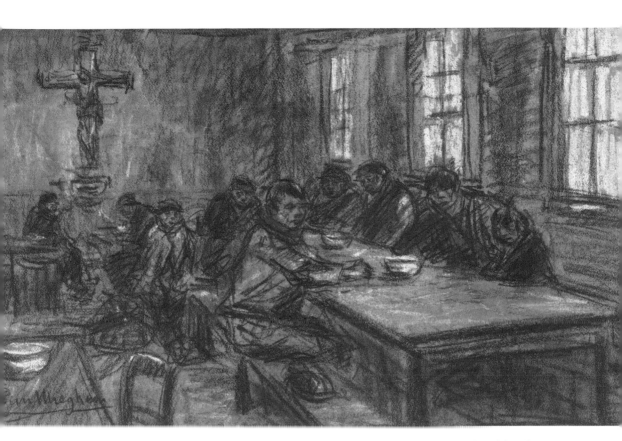

In the refuge, 1914
colored chalk, 39 x 62 cm
private collection

that, ten years after crafting his sympathetic drawings of Jewish emigrants, the artist himself was one in a flood of refugees. Even during the chaos of flight he continued to draw, recording like a reporter the looks of fear and dejection on the faces of those around him. Van Mieghem's mother, who had given her son financial security, several weeks after Antwerp was taken, returned to her livelihood, the café on Montevideo Street. Van Mieghem himself returned to Antwerp and remained in the occupied city throughout the war years. His art of the period reflects what he saw as he wandered through his beloved city, with its almost dead port, and helped in the soup kitchen started by the Franck family, among others. What emerged were the highly emotional drawings of children in need. As well, his observations of the German army only strengthened his pacifist convictions and resulted in sharp caricatures of the German Kaiser Wilhelm II. During a house search by German soldiers Van Mieghem was able to hide these biting political cartoons only just in time.

The Post-War Years (1919-1930)

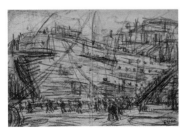

Ship at berth, 1917
brown and red chalk, 17 x 25.8 cm
private collection

In January 1919, the writer and art-critic Georges Eekhoud mentioned in his essay *"Onze schilders van den werkman"* (Our Painters of the Working Class): " ...elsewhere Van Mieghem depicts the unemployed, loafers, idlers and he lets us, with an almost paradox, but triumphant pleasure, admire their roughness..."

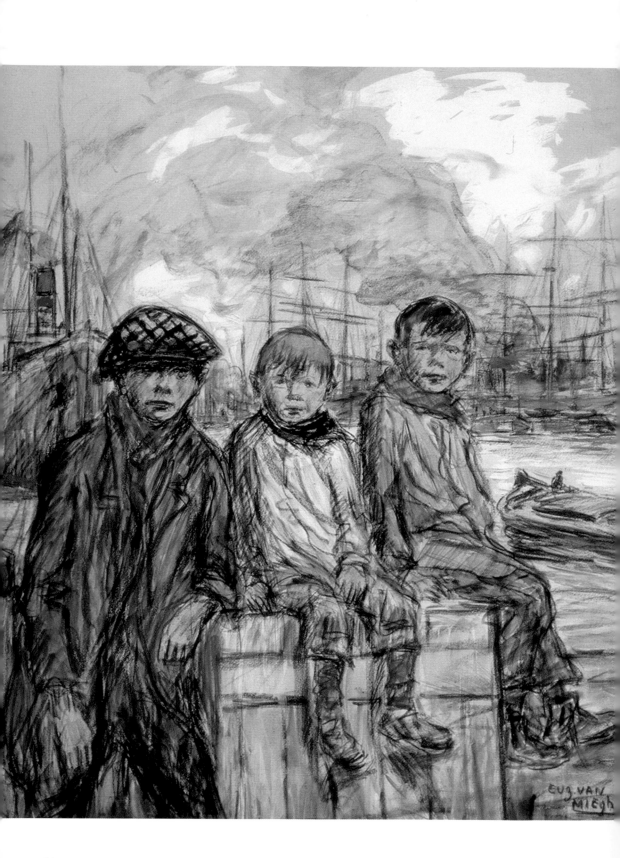

left:
Loafers of the Antwerp docks, 1919
watercolor, 78 x 72 cm
private collection

Shortly after the end of the First World War Van Mieghem's mother sold her inn and went to live in a retirement home. The artist moved to the opposite side of the harbor, to Kattendijkdock-Eastquay nr. 4. In March 1919 he showed his extensive war œuvre at the Koninklijk Kunstverbond but achieved little commercial success. The liberated people of Belgium did not wish to be reminded of wartime suffering and his work did not sell. Vastly different, however, was the response from the critics, who were justifiably comparing him to Steinlen, Forain and Kollwitz.

In the art-magazine *Onze Kunst* (Our Art) Ary Delen wrote: " ...The fact that, now that the war has finally ended, the inevitable war-art, emerges in our country, should not surprise us. The tremendous event undoubtedly had a very profound impact on our artists, having either fought at the front themselves or struggled through their life in deprivation in the occupied country. Nevertheless, in such a monotonous abundance, it is difficult to come across the testimony of a truly deep emotion. The works we have seen up to now, with a few rare exceptions, are painstaking and fairly mechanical, more rational than emotional. Van Mieghem's work is one of the exceptions. A very exceptional artist, he is one of those people, who look upon life with a sharp, thorough, analytic mind, not superficial at all. This has gained him a place of his own, because his temperament shows little or no affinities with the Flemish tradition, which on the whole is more

The night watchman, 1923
oil on panel, 40 x 64 cm
private collection

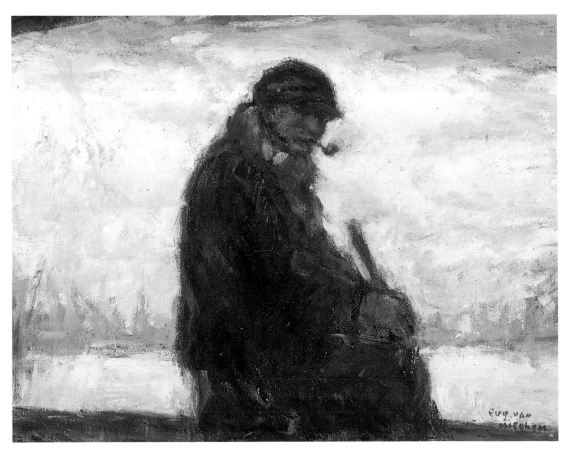

occupied with the blooming of color and forms. He is related to the great
French draftsmen following Steinlen and Forain, to whom he owes a lot,
especially to the former, whose influence prevails in the artist's work.
Technically speaking at least, because hardly anything of Steinlen's
humanitarian drifts nor Forain's sharp sarcasm can be espied in
Van Mieghem's work. His "tranches de vie" are true-to-life perceptions
of the life of down-and-outers, the bourgeoisie and the street rabble.
His only reason for depicting them is their typical and picturesque character,
the unique silhouettes, the special gesture or stirring pose. He very seldom
feels inclined to philosophize or argue... Van Mieghem's war work belongs
to the very best in its genre and most certainly measures up against that
of well-known and much talked-of foreigners. Therefore this promising
artist deserves much more than the little with which he has contented
himself up to now in his quiet reserved nature..."

Van Mieghem's war output is unique in Belgian art. Other artists rendered
some war themes, but with far less diversity in subject matter. Moreover,
Van Mieghem's war work was a continuation of his themes of pre-1914.
He remained faithful to his ideal of portraying the ordinary man in the
surroundings of his everyday life. As before, with his drawings and
paintings of the port proletariat, there were no commercial motives to

The little rascal, 1923
oil on panel, 59 x 90 cm
private collection

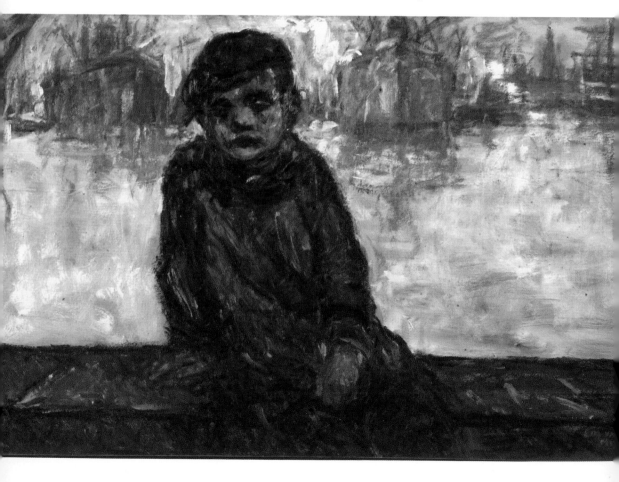

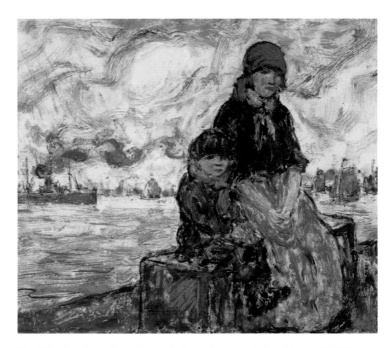

Van Mieghem's work. Exhausted, the artist was admitted in April 1919 to the sanatorium Le Fort Jaco in Ukkel, a rural suburb of Brussels. There he met the 24-year-old nurse Marguerite Struyvelt (1895-1940) and, despite her youth, began a relationship with her. She later accompanied him back to Antwerp, where she lived with him. In May a second exhibition of Van Mieghem's war works took place in Scheveningen (Holland), in the Gallery H. De Graef.

In September he took part in the *Salon des Aquarellistes Belges* (The Belgian Watercolor Society) in Brussels, where his work was noticed by the Belgian novelist Georges Eekhoud (1854-1927), who wrote: " ... and especially two colored drawings by Eugeen Van Mieghem, long admired *"In het droogdok"* (At the dry dock) and *"Dokschuimertjes"* (Loafers). This last work, little loafers of the Antwerp docks, represents probably the core of the exhibition. One could not imagine anything more lively or realistic; it is chosen and observed at the same time. Here good taste and feeling go together with a masterly technique. It is local and very human..."

Eekhoud was best known for his ability to represent scenes from rural and urban daily life. He tended to portray the dark side of human desire and in his novels about social outcasts and the working classes. On September 19th, Eekhoud sent Van Mieghem the following letter: "Dear Artist, I just came from the salon des aquarelistes were I was marveled by your lads on the border of the Scheldt... I have followed you for a long time, with growing interest, and I now have immense admiration for your intense artistic feeling and magisterial technique. Your subjects are almost made to make me passionate..."

On November 5th a second letter followed: " ...the nature of your art, your favorite subjects, our Antwerp docks with their population that is so

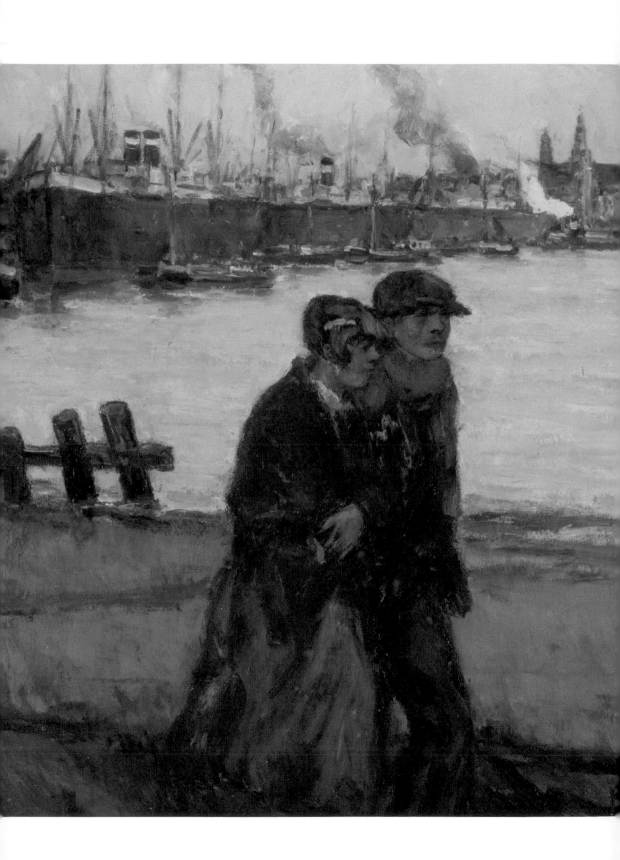

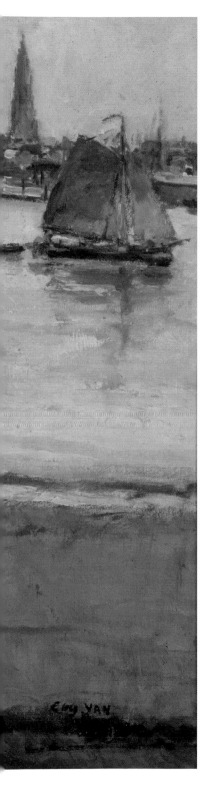

characteristic and tasteful, at the time shy and open make your talent more sympathetic and precious to me than that of others; especially because of your masterly skill and your wit, the feelings you put in all your creations that are inspired by the people of our race. It is regrettable that the State does not find it more important to support and encourage the artists of your type, so nationalistic, patriots in the noblest sense! But alas, as with religion, patriotism seems to be only interested in rubbish and bad painting. This incompatibility between art and official interest seems to always have existed..."

On March 22, 1920 Van Mieghem was appointed Professor at the Antwerp Academy for the class "Drawing after Classical Sculpture" by Minister Jules Destrée. In fact, however, Van Mieghem taught the class in life drawing, and soon became popular. A former student wrote: " ...Van Mieghem took his time to make corrections and gave us the advice to always carry a sketchbook with us, to immediately register the interesting things one encountered. He used this technique himself brilliantly..."

On November 10th of that same year Van Mieghem married Struyvelt. His son Eugeen accepted this marriage with difficulty and enlisted as a steward on the flagship Belgenland of the Red Star Line.

In 1921 Van Mieghem participated in the annual *Kunst van Heden* exhibition by entering nine works. In 1922 the artist concentrated his efforts on the craft of monotype, a difficult technique at which Degas excelled. That year, *Kunst van Heden* honored the French Master who died in 1917 by showing 72 of his works. A year later, Van Mieghem was mentioned by Pol de Mont in his new book *"Painting in Belgium from 1830 to 1921"*: "...he, whose scenes from the lives of the poor bastards from the port, often depicted with a tragic undertone, executed in a strange color, never were enough appreciated by the so-called art-lovers..."

By mid-1922 Van Mieghem and his wife had moved to 30 St. Paulus Street, several hundred meters along the Van Meteren Quay, where he was born, and within walking distance of the Antwerp Academy. The artist was back in his original neighborhood.

The period at St. Paulus Street was a thriving one for the artist. In April 1923 the artist showed 28 works in the annual *Kunst van Heden* exhibition. Cléomir Jussiant, one of Antwerp's newly rich collectors, bought his oil painting *"Havenboefje"* (The rascal of the port) and during the Triennial Salon in September the Antwerp Museum of Fine Arts bought Van Mieghem's watercolor *"Vrouwen aan de haven"* (Women on the docks).

Around that time Van Mieghem became a friend of Ernest Van den Bosch (1879-1936), who was the secretary of François Franck. Franck's furniture business, Ameublements Franck, was so profitable that his own holdings soon became more important than those of his rich clients. Franck decorated his home in Everdijstraat in a unique refined style; the house, where many major meetings were held and deals made, looked more like a private museum. Van den Bosch soon shared his employer's passion for collecting.

Franck owned the country's largest collection of paintings by the renowned Belgian artist, James Ensor (1860-1949), a painter whose unique renderings

of grotesque humanity made him a principal precursor of 20th century Expressionism and Surrealism.

In May 1924 Van Mieghem showed his most important exhibition, of 36 works, at *Kunst van Heden*. De Mont, now chief editor of the newspaper *De Schelde*, wrote: " ...I do not believe that of all the visitors to this salon anyone could be more pleased about Eugeen Van Mieghem's participation than I was. I, who have kept so many pleasant, partly other but never banal and always positive memories of this typical boy from the Boatmen's quarter. Not only from the blessed period that he, at secondary school and at the Academy, followed my lessons, but also later! ...even much later. I have seen Van Mieghem grow, not only as a man, but also as an artist... Speaking of strong work, the series of small drawings and monotypes that complete his contribution contain a lot that will make the most knowledgeable longing for it... The City of Antwerp should buy this whole series for the new "Foundation for Drawings and Graphic Arts" (the Municipal Print Room). It would be money well spent!"

Baron Lheureux, a well-known banker, bought the painting *"Havenvrouwen"* (Harbor women) at this show. In July and August the artist had a busy correspondence with Paul Lambotte, director of the Department of Fine Art of the Belgian government, about the possible purchase by the Belgian government of the painting *"Aan de dokken"* (At the docks). Unfortunately, the sale did not take place.

In July 1925, Van Mieghem went on holiday alone to Blankenberghe on the Belgian coast, as his relationship with Struyvelt was ending. In Ostend he called on Ensor, and during this visit drew the old master. At the end of March 1926, two of his works were included in the *Exposition de l'Art belge ancien et moderne* (Exhibition of Old and Modern Belgian Art) organized by the Belgian government in Bern, Switzerland. Both paintings were sold. The *Kunst van Heden* show of May 1926 was completely dedicated to the modern French School, a result of the collaboration between François Franck and the French writer and critic Georges Waldemar to select the best works by the most famous Parisian artists, including Picasso, Matisse, Rouault, Braque, Dufy, de Vlaminck, Laurencin, Utrillo, Modigliani and Dunoyer de Segonzac. The influence of some of these artists is evident in Van Mieghem's work directly following this exhibit. Although Van Mieghem occasionally experimented with new art forms, he quickly returned to his preferred port subjects.

In May, his friend Lode Baekelmans was honored for his 25 years of published writings, and on this occasion his friends gave him Van Mieghem's painting *"Langs de Schelde"* (At the river Scheldt) (see cover illustration). In July of the following year (1927), the artist was admitted to the Dennenheuvel sanatorium in Ossendrecht, just across the border in Holland. From there Van Mieghem corresponded with Baekelmans about an article that Baekelmans was writing about the artist for the magazine *De Vlaamse Elsevier*.

Unfortunately the richly illustrated piece that came out in November was more a lyrical description of the Antwerp port of their youth than a detailed chronicle of the life of the artist. However, it does list the modern artists Van Mieghem liked, such as Breitner, Meunier, Millet,

Still life with bananas, ca. 1929
monotype, 19 x 25 cm
private collection

Still life with bottles, ca. 1929
black chalk, 10.5 x 14.1 cm
Haarlem, E.J. van Wisselingh & Co

Still life with brushes, ca. 1929
black chalk, 10.7 x 14.5 cm
Haarlem, E.J. van Wisselingh & Co

Still life with hat, ca. 1929
black chalk, 10.6 x 14.6 cm
Haarlem, E.J. van Wisselingh & Co

Mother and child, 1926
oil on paper, 40.5 x 33.6 cm
private collection

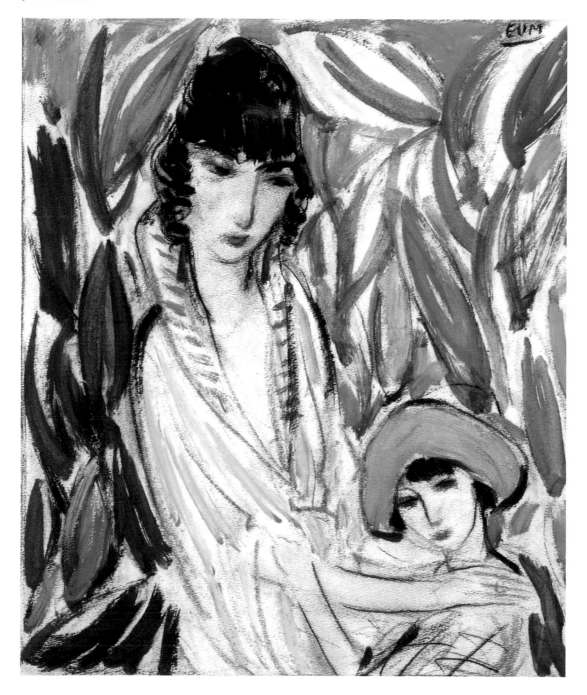

Toulouse-Lautrec, Steinlen and Forain. Baekelmans further wrote: " ...He is a depressed, one who has tasted the bitterness of life, has read everything, is disillusioned and yet full of longing and love for what the meager human life has to offer."

The article failed to mention the tragic death of Augustine, Van Mieghem's first wife. Shortly before publication of the November issue of *De Vlaamse Elsevier* the Budapest Museum of Fine Arts bought a painting from Van Mieghem during an exhibition of Belgian art held in Hungary. Back in Antwerp, the lonely and sad artist spent his evenings patronizing the pubs and brothels of the boatmen's quarter.

Still life with decorative dish, ca. 1929
black chalk, 10.2 x 14.7 cm
London, Wolseley Fine Arts

In February 1928 Van Mieghem took part, for the last time, in *Kunst van Heden.* He showed only four works. But during the summer months several of his paintings were included in the exhibition, *Junge Belgische Kunst* (Modern Belgian Art) at the Kestner-Kunstgesellschaft in Hannover, Germany. At the beginning of 1929 Van Mieghem maintained a busy correspondence with his friends Baekelmans and Van den Bosch, in which he made remarks about his health, which was worsening. While resting at home during this period, he made monotypes and approximately sixty small drawings of everyday objects from his environment. These small still lives in black crayon reveal as much about the personality of Eugeen Van Mieghem as about his living quarters. In particular, they reflect his exacting standards, even when rendering somewhat banal objects.

The alarm clock, ca. 1929
black chalk, 9.8 x 17 cm
Haarlem, E.J. van Wisselingh & Co

The question of why Van Mieghem was inspired to draw this series of still lives remains a mystery. It is possible that Van Mieghem owes an artistic debt to his contemporary, the Italian artist Giorgio Morandi (1890-1964), who was renowned for his still lives. For Morandi, the still life was the key to the interpretation of reality. His paintings betray an unending search for perfect composition, for elimination of the extraneous; with a few sharp lines and subtle colors he evokes the soul and the essence of the simplest objects. His style is very personal, uninfluenced by other art movements, and his preference was for earth tones and white. He especially focused on still lives of objects, whose contours he deliberately blurred. Human figures are simply not present in Morandi's art. During 1928 Morandi's fame grew as a result of his participation in the Venice Biennale, so it is possible that Van Mieghem came into contact with his work shortly thereafter.

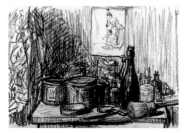

Still life with artist materials, ca. 1929
black chalk, 10.6 x 14.8 cm
Haarlem, E.J. van Wisselingh & Co

In his pocket diary of 1929 he made daily sketches and notes about appointments with lawyers (the divorce agreement with Struyvelt was working its way through the Brussels courts) and doctors. In this notebook are quotes from writers and artists such as Guido Gezelle, Sainte-Beuve, Villiers de l'Isle Adam, van Dongen, Goethe, Balzac and Fichte. In July he also made some scribbles after the fashion of Cézanne, in October after Modigliani. On August 29 the artist wrote to his friend Ernest Van den Bosch. He complained that two members of *Kunst van Heden* were keeping him in the dark about a possible purchase of his work that one of them had had in his possession for more than nine months. In a mood of resignation he ended his letter with the sentence: " ...At the end, most artists are poor beggars, including myself, and will always stay that way..." In September 1929 the artist participated again in the *Salon des aquarellistes belges* in Brussels. It would be his last exhibition.

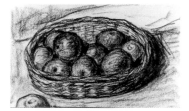

Still life with apples, ca. 1929
black chalk, 9.3 x 15.5 cm
London, Wolseley Fine Arts

In 1930 Van Mieghem wrote down the following entry by Rainer Maria Rilke on the first page of his new diary: " ...Maybe it will appear that you have the vocation to be an artist, then accept that fate, and bear it, with all its weight and importance, without ever expecting any reward from the outside. Because the person who creates has to have a world of his own, he finds everything within himself and in the world he has made his own".
On March 24, 1930, Eugeen Van Mieghem died of a heart attack. He was only 54 years old.

After His Death

The day after his death the Belgian newspapers were full of posthumous praise: " ...Van Mieghem has died at an age in which his work was coming to its full ripeness. Antwerp loses one of its most beloved sons and Flanders has lost a great artist. But the work of Van Mieghem will stay alive as an everlasting and real beauty."

The departure, 1912
pastel and charcoal, 48.3 x 62.9 cm
Antwerp, Municipal Print Room

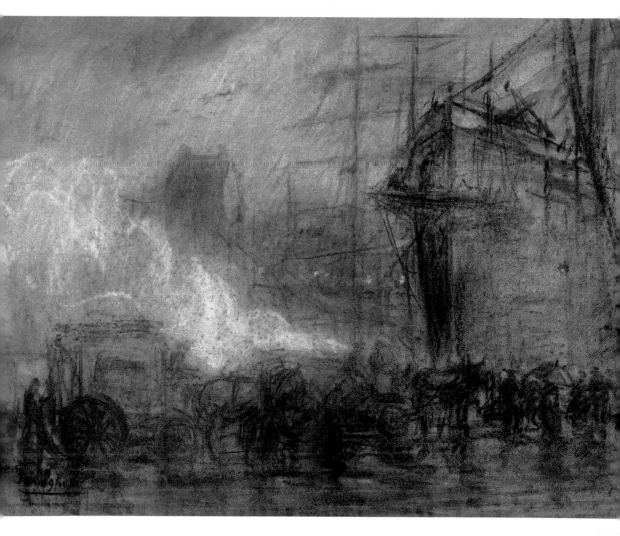

The World Exhibition in Antwerp
photograph, 1930
Antwerp, Van Mieghem Museum

The Antwerp writer and art critic Lode Zielens in *"A Glorifier of the
Antwerp Docks"* described his work: "...his painting preserves the sharp
and merciless sense of reality, but the beautiful, often visionary color
transposed it all to a heavenly reality. Van Mieghem was a colorist of
rare merit. His color was the reflection of a rich mind that did not know
deadness or meanness..."

At the 1930 World Exhibition, which took place in Antwerp, *Kunst van
Heden* had a pavilion in which a Van Mieghem retrospective containing
about a hundred works was held from May 31st through June 12th.
Arthur H. Cornette, Curator of the Antwerp Royal Museum of Fine Arts,
wrote the introduction to the small catalogue: " ...he was a draftsman of
the race of Steinlen and, however less captured by the proletarian suffering,
of Käthe Kollwitz; he did not show that work often enough, modest as he
was, in comparison to his more than normal talent and he piled up his
daily work in the drawers of his cupboard. Pencil and crayon drawings,
watercolors and pastels are lying there by the hundreds, maybe the most
complete document of the Antwerp harbor that we possess, of an intense
democratic, pessimist character and full of sadness. It lies asleep now in
the heritage of this honest artist that disappeared young. May it be totally
appreciated when it will once see the light!"

The selections were made by the son of the artist, who inherited all his
father's works. Van Mieghem had kept everything, from his earliest
childhood drawings to his last sketches. Because of the rush to compile
the retrospective, there was no time to study the work thoroughly. The
exhibition lacked a time line. Cornette obviously sensed this omission in
the retrospective and he expressed his hope that time would bring justice.
Van Mieghem's son took the initiative in 1930 to publish 30 portfolios
with 30 etchings printed posthumously. Shortly thereafter the Belgian
government bought two paintings for the collection of the Antwerp Royal
Museum of Fine Arts. Soon after the son organized two more retrospective
exhibitions: one at the Brussels Galerie d'Art Kodak and one at the Antwerp

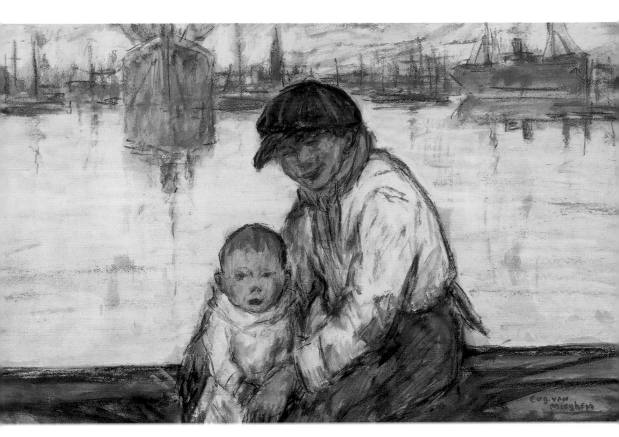

Two brothers, 1923
oil on paper, 40 x 64 cm
private collection

Koninklijk Kunstverbond. Between 1931 and 1940 Van Mieghem's work
was included in many important group exhibitions. In Holland, former
Yugoslavia, Finland, Norway and Sweden, Van Mieghem's paintings were
exhibited next to the works of the most important Belgian artists such as
James Ensor, Jakob Smits and Rik Wouters. In 1932 Baron Lheureux
(a supporting member of *Kunst van Heden*) donated three Van Mieghem
works to the Museum of Belgrade. François Franck died after a freak
accident in Ostend on March 23, 1932. In the book honoring the
Antwerp collector that came out in 1933, A.H. Cornette wrote:
" ...He supported a group of young people like Rik Wouters, Permeke,
the Jespers brothers, Crahay, Van Mieghem..."

During their lifetimes François and his brother Charles made large
donations to the Antwerp Royal Museum of Fine Arts. After the death of
his father François, Louis Franck Jr., made a loan of the famous painting
by Ensor *"De intrede van Christus in Brussel"* (The Entry of Christ into
Brussels). Years later, when Louis Franck, Jr., visited the Antwerp
Museum and discovered that the Museum management had not kept the
François Franck Room and its collection intact, he sold Ensor's masterpiece
to the Getty Museum in Los Angeles.

In 1944 the Antwerp city council organized a Van Mieghem retrospective
at the Stedelijk Kunstsalon (City Art Salon). This small exhibition
aroused local interest. The artist Edmond Van Offel, a former friend of

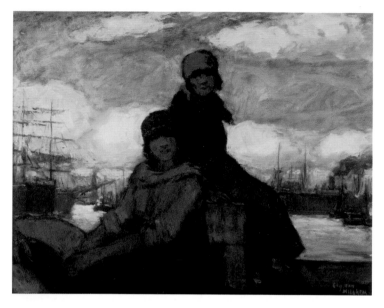

Women of the port, 1924
oil on canvas, 55 x 70 cm
private collection

Van Mieghem, wrote a short monograph: " ...He followed his own way undisturbed and wanted to be who he was. Van Mieghem has remained himself without effort. One line, a rising line, trying to achieve complete mastering of expression... His execution is harsh, because his subject matter makes it harsh. He strives for greatness, for a synthetic power with which he wants to express his vision on the world... For a painter is fortunate if he is born amidst what he can love as no other and where he will find this inspiration; he who knows how to understand this luck and to accept it, listens to a wise voice. Van Mieghem did..."

Unfortunately, towards the end of the Second World War, many of Van Mieghem's documents, letters and books were lost in a fire. His tombstone monument, depicting a seamstress of the port, by the well-known sculptor Oscar Jespers (who also made the tombstone monument for François Franck) was also lost. These losses were symbolic of the waning interest in Van Mieghem's work after the Second World War, due to the national and international interest for more recent artistic expressions.

In 1951 Marnix Gijsen (a pseudonym for Dr. Jan Albert Goris), who worked as cultural attaché for the Belgian Consulate-General in New York, published a booklet entitled *"Drawings by Modern Belgian Artists"*. In addition to the illustrations of two master drawings from the collection of the Antwerp Municipal Print Room, he wrote about Van Mieghem: "...he was a draftsman of uncommon power... the greatness of the splendid image above can stand up next to Toulouse-Lautrec and the great masters..."

In 1958 another retrospective was organized by admirers, of which the Flemish writer Hubert Lampo remarked: "...we think there is nothing worse than the ungratefulness towards a real artist, whose life and striving have been for an admirable longing for artistic and human truth..."

When the heirs of François Franck auctioned part of the inheritance in 1965 in the Palais des Beaux Arts (Palace of Fine Arts) in Brussels,

the catalogue contained four works by Van Mieghem. The oil painting *"Personages"* was acquired by the famous Brussels collector Olga Bernheim. Around this time the Antwerp provincial council bought two of his paintings.

The Rehabilitation

On August 16, 1982, the Eugeen Van Mieghem Society was founded. The support and the sympathy of the entire community of Antwerp were immediate. The first retrospective with chronological arrangement of his work was held three years later at the Jakob Smits Museum. In 1987 the Antwerp Municipal Print Room organized the exhibition, *"Eugeen Van Mieghem and the Port of Antwerp"*. For the first time the most important works of this impressive collection of over 600 works were shown to an enthusiastic public.

Curator Dr. Fr. de Nave wrote in the catalogue: "...because of the imposed soberness in means and the expressive use of line Eugeen Van Mieghem managed to achieve an indisputable greatness in his art that we especially see in the synthetic power his work radiates. As such he has not become an innovator, but he was an honest and sensitive artist who was only moved by his heart without worrying about what was propagated by the new art movements. His artistic heritage is of great value to us, not only as the work of a very decent artist, who has shown himself especially as a great draftsman and whom we may count among the most skilful representatives of our realist school..."

A young boy with a cap, 1907
black chalk, 20.2 x 13 cm
private collection

This renewed attention brought to light previously unknown works letters, documents and data in private collections that gave his output a new dimension. As a result of the years of research in Belgium and abroad the whole of Van Mieghem's life was taking shape, like the pieces of a jigsaw puzzle fitting together. The Foundation published annual illustrated monographs about a specific aspect of his art; limited facsimile editions of his sketchbooks also were printed. In March 1991, Stephanie Billen wrote in *Antique Monthly*: " ...although the Belgian artist sold very little in his lifetime and was reduced to painting on the back of posters and advertisements because he could not afford paper, he had a marvelous raw talent..."

Study of emigrants, ca. 1911
blue chalk, 18.5 x 12.8 cm
private collection

On March 24, 1993, the Eugeen Van Mieghem Museum opened in Antwerp. On October 1st of the same year *"An Artist of the People"*, the first art book by Erwin Joos on Van Mieghem's life and work was published. This book identifies the drawings of Augustine Pautre, Van Mieghem's first wife, who died of tuberculosis in 1905. On a visit to the home of Eugeen Van Mieghem Jr. in 1982, a beautiful portrait of a young woman was observed in his living room. Van Mieghem Jr. did not know that this was his mother. In his review of the book in April 1994, the art critic Joost De Geest appreciated the artist's importance in a broader context: " ...there is no doubt that Van Mieghem, especially with his drawings and graphical work, deserves a place in Belgian social art, next to Meunier and Laermans. But we should also see his work in an international context next to Steinlen, Forain and the German realists."

In the summer of 1995 Het Markiezenhof in Bergen op Zoom,
The Netherlands, was the first museum outside Belgium to organize
an important Van Mieghem retrospective. The curator Dr. Johanna
Jacobs wrote in the catalogue: " ...that this re-evaluation is more than just
is proven by seeing the work. Not only does it evoke emotions of sympathy
and compassion, but Van Mieghem's oil paintings, charcoal drawings,
graphic work and pastels are also purely aesthetically a proof of
Van Mieghem's virtuosity. Especially in the last category we see a master
working in chalk that is only matched by few others..."

Dutch art critics reacted enthusiastically: " ...his rather somber canvasses
and drawings show the sad social reality of anonymous people used as
poorly paid workforce. It is a form of social realism in art that in Holland
has not really found a reason to be... The people on his canvasses and
drawings don't have a name. They are no individuals with their own
character that the artist depicts, but characters that depict a social class."
(Frits de Coninck).

Afterwards, other major retrospectives were organized in The Netherlands
(Museum Schielandshuis in Rotterdam and the Jewish Historical Museum
in Amsterdam), Germany (Wernigerode Castle, the Käthe Kollwitz
Museum in Berlin and the Ernst Barlach Haus in Hamburg), Switzerland
(the Neumann Foundation in Gingins) and the United States (the Ellis
Island Immigration Museum in New York City). As a result major
international art galleries have also discovered his work (such as Wolseley
Fine Arts of London and E.J. van Wisselingh & Co. in Haarlem, Holland).

right:
Brother and sister (detail), 1927
mixed medium, 37 x 48 cm
Antwerp, Van Mieghem Museum

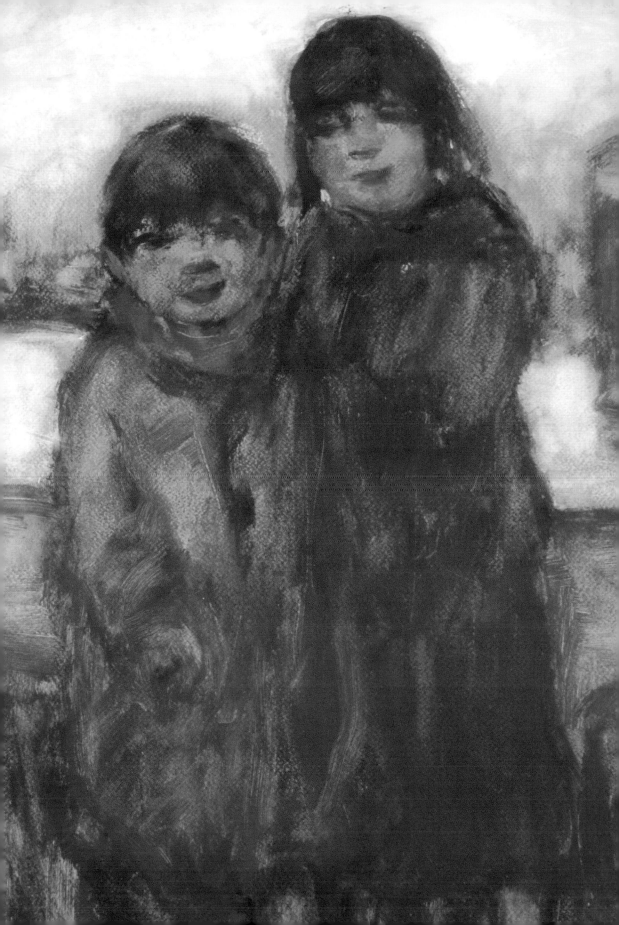

3. The Emigrants of the Red Star Line

The First Red Star Line: New York - Liverpool

The first Red Star Line began operations on January 25, 1822, when the Meteor, under the command of Captain Nathan Cobb, sailed from New York on her maiden voyage. Regularly scheduled packet service between New York and Liverpool was soon available, a big advance over the service previously provided since 1818 by the Black Ball Line, whose four sailing packets made the Atlantic crossings at irregular intervals.

Two Quakers who worked in the flour trade, Thomas S. Byrnes and George T. Trimble, started the line to expand their core business. These ships sailed under the American flag, and bore a house flag of a blue swallowtail pennant with a red star in the center, which also flew on the foretopsail.

Two emigrants, 1904
black chalk, 21 x 13 cm
private collection

The Red Star Line made its departures from New York on the 24th of each month and on the 12th of each month from Liverpool. The voyages took from four to five weeks, depending on the season, the weather conditions, and the direction. Westbound voyages, from Liverpool to New York, took anywhere from eight to fourteen days longer. Over the years, as larger packets were built, these travel times shortened considerably, with crossings taking just over two weeks.

When Thomas S. Byrnes died in 1825, his shares were taken over by Samuel Hicks and his sons John and Henry. In 1835 they sold the Red Star Line to Robert Kermit, one of the most experienced shipping managers of his time. Later that year he went into partnership with Isaac Quentin Carow, establishing the shipping firm of Kermit & Carow, which operated the Red Star Line out of New York from 74 South Street and from Pier 19 on the East River.

Charles Carow, the son of Isaac, ran the Red Star Line after Robert Kermit died, but in 1867 regular sailings were discontinued, replaced with occasional service on the large packets, the Constellation, weighing 1,568 tons, and the Underwriter, which weighed 1,168 tons, until the end of 1869. In 1886 the daughter of Charles Carow, Edith Kermit Carow married Theodore Roosevelt on December 2nd. In 1901 he became the 26th President of the United States.

Emigrant (somber), 1904
black chalk, 21 x 13 cm
private collection

right:
(above): The Red Star Line warehouse
postcard, ca. 1904
Antwerp, Van Mieghem Museum

(below): At the Red Star Line warehouse
(dedicated to Pol de Mont), 1902
colored pencil, 25 x 35 cm
Antwerp, Van Mieghem Museum

Anvers Départ d'émigrants

Madammeke

A 4225 Wilhelm Hoffmann A.-G., Dresde

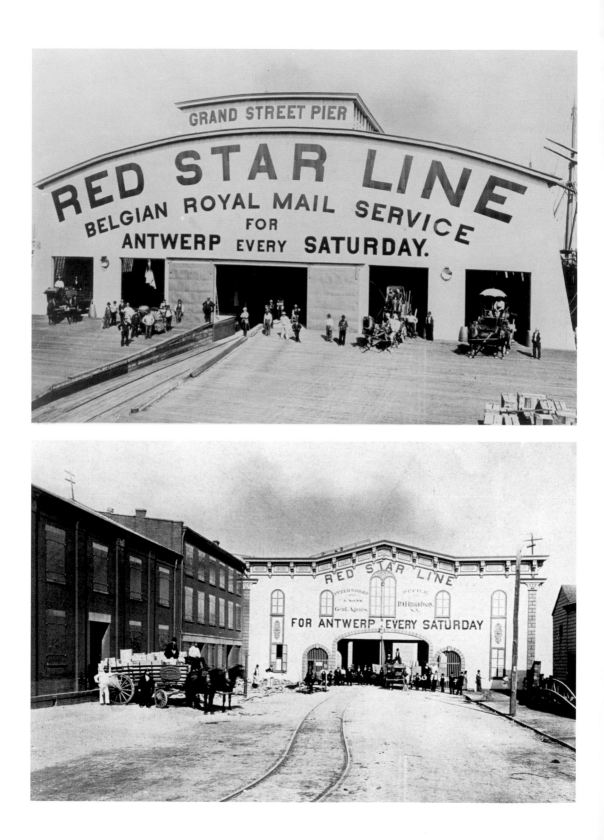

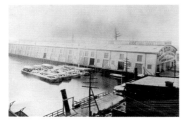

Red Star Line (Grand Street Pier,
New York), photograph, ca. 1900
Antwerp, City Archives

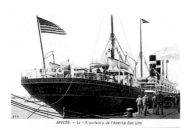

The Kroonland
postcard, ca. 1915
Antwerp, Van Mieghem Museum

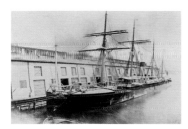

The Rhynland in the port of New York
photograph, ca. 1900
Antwerp, City Archives

left (above and below):
Red Star Line
(Grand Street Pier, New York)
photograph, ca. 1900
Antwerp, City Archives

Bill of lading Red Star Line
18 November 1893
Antwerp, Van Mieghem Museum

The Second Red Star Line: Antwerp - Philadelphia/New York

In 1872 The Belgian Red Star Line shipping company was founded
(under the official name SANBA). It was owned by a consortium
whose principal shareholder, with 2,749 shares, was C.A. Griscom of
the International Navigation Company of Philadelphia. The minority
Belgian shareholders were the local Antwerp businessmen von der Becke
and Marsily, each with ten shares, who were experienced importers of
refined petroleum, which at this time was shipped from Philadelphia in
sailing ships carrying cargos of 5,000 to 10,000 barrels.

The main purpose of the line was oil imports from America.
The International Navigation Co. was founded in Philadelphia in 1871
by a group of financiers mostly wealthy industrialists and company
directors from Pennsylvania. They were involved in the building of
railroads of the eastern United States that burgeoned in the mid-1800s,
principally, the powerful Pennsylvania Railroad Company. The intent
behind the formation of the Red Star Line was to operate it as a Belgian
subsidiary between Antwerp and Philadelphia with ships registered in
Antwerp, flying the Belgian flag. This arrangement enabled the ships to
be built in England at a cost considerably lower than those built in
American shipyards. By law ships registered in the United States that
flew the American flag could not be built abroad, because the American
government wanted to promote construction in domestic yards and the
formation of an American merchant fleet. However, there were no
restrictions on owning or chartering ships sailing under foreign flags.

Another trans-Atlantic line was established and brought into service
at the same time. The American Steamship Company, known as the
American Line, was created with the financial backing of the
Pennsylvania Railroad and the drive of the young and brilliant shipping
merchant Clement A. Griscom. This line would operate a service between

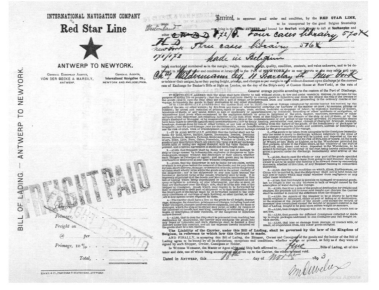

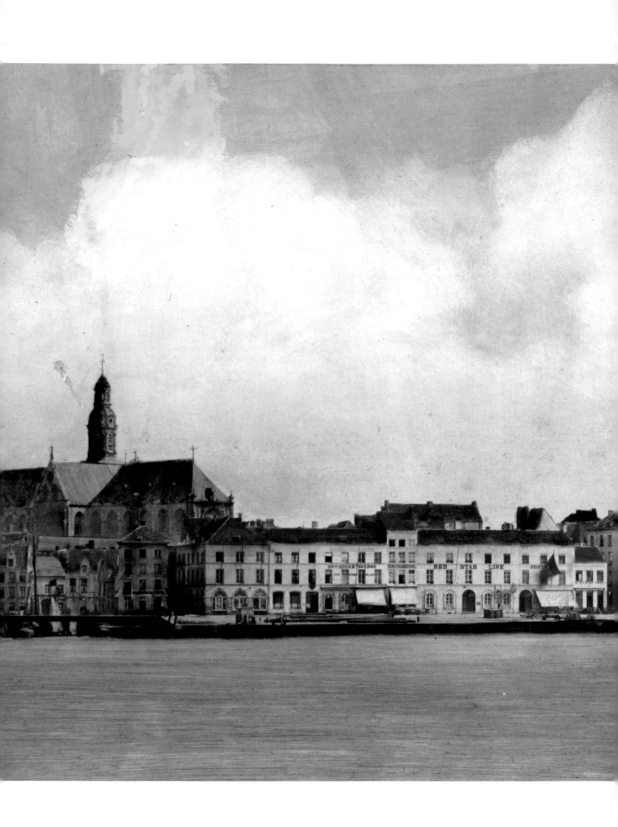

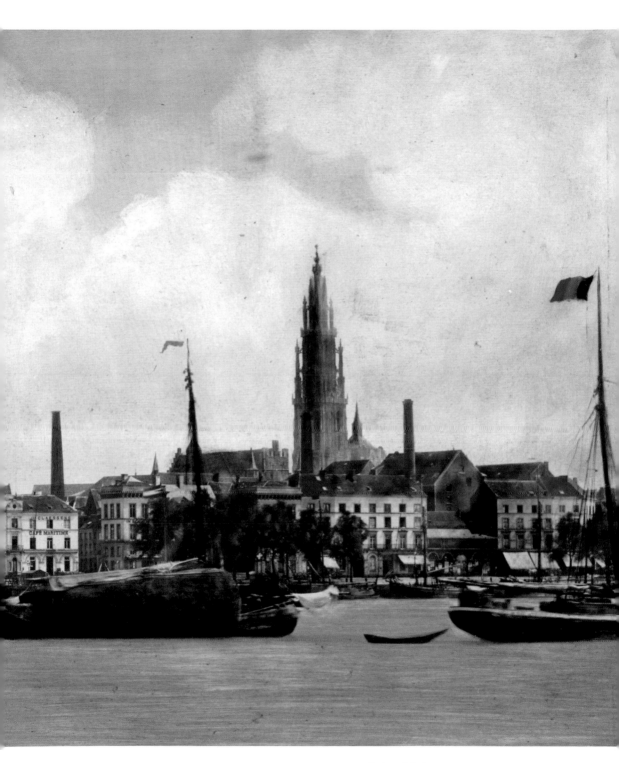

A view of Antwerp
(with the Red Star Line office on the Jordaenskaai)
photograph, ca. 1880
Antwerp, Van Mieghem Museum

75

Philadelphia and Liverpool, then the most important gateway to highly industrial Britain. The ships were built in Philadelphia shipyards, sailed under the American flag, and were manned with American crews.

The name "Red Star Line" was no doubt adopted by the International Navigation Company because of the prominence and sound reputation the company achieved over nearly fifty years of trans-Atlantic service. It had name recognition in the minds of businessmen, shipping and forwarding agents. The general agent in Philadelphia was the firm of Peter Wright & Sons, with whom Clement Griscom of the American Line was in partnership.

The two steamship companies were in close relationship from the start. The first line consisted exclusively of sailing ships operating between New York and Liverpool; the second line consisted of steamships running on the Philadelphia and Antwerp route, with New York added within a year.

Traditionally, privately held companies tended to maintain ownership over successive generations, in active or silent partnerships. This was probably the case with the two Red Star Lines. There is no other instance in maritime history of a new shipping company adopting the name of another, either recently extinct or from the distant past. The first Red Star Line had barely ceased operations when the second line was planned, with an identical style of house flag. The second Red Star Line sailed under the Belgian tricolor, and its house flag had a white burgee with a red star in the center. Funnel colors were buff with a red star underneath the black topping. The hulls had a red line from stern to stern.

The first Red Star steamship was the Vaderland, launched on August 21, 1872, and delivered to the owners in early January 1873. She measured 2,748 tons, 320.5 ft. in length, 38.5 feet in width, and 23.8 feet in depth. She was fitted with a four-bladed screw, was iron-built, had masts and was brig-rigged as single-screw ships were at that time in order to provide sail when needed. Her service speed was 13 knots (15 miles per hour). The Vaderland had been specially constructed and reinforced with a double bottom to carry petroleum in bulk tanks, and was in fact the first oil tanker ever built.

The Belgenland I, lithograph 1879
Antwerp, Van Mieghem Museum

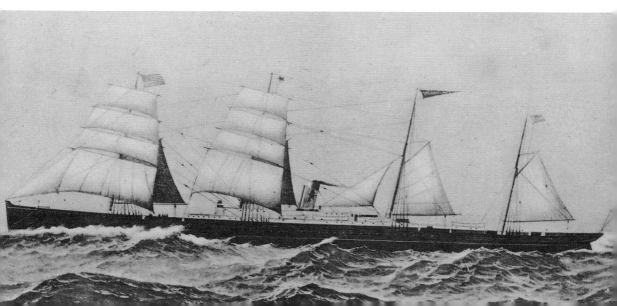

The Noordland
photograph, ca. 1895
Antwerp, Van Mieghem Museum

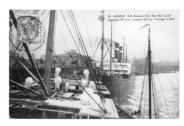

The Zeeland
postcard, ca. 1905
Antwerp, Van Mieghem Museum

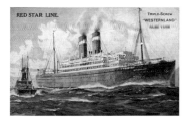

The Westernland
postcard, ca. 1930
Antwerp, Van Mieghem Museum

Red Star Line, postcard, ca. 1900
Antwerp, Van Mieghem Museum

overleaf: Red Star Line postcards
Antwerp, Van Mieghem Museum

The ship was designed to carry petroleum as the regular main cargo from Philadelphia to Antwerp. Demand for oil was now growing rapidly; for carriers, the potential profits were high and the future looked promising. Everything was in place to capitalize on this market, including the experience and connections of the company's Antwerp agents. However, the American authorities denied permission for security reasons and the Belgian authorities also refused to allow bulk storage tanks to be constructed on the Red Star Line quayside premises in Antwerp. Consequently, the intended purpose was abandoned, and the company specialized in the lucrative business of transporting emigrants. In 1880 alone the Red Star Line carried almost 25,000 passengers from Antwerp to America.

The Vaderland was followed by the Nederland and the Switzerland. All ships owned later by the Red Star Line would have names ending in -land (such as the Belgenland, the Finland, the Friesland, the Kroonland, the Lapland). The passenger accommodation of the three ships was intended primarily for the transport of emigrants, with provision for 800 in third class, plus approximately 70 in first and second cabin. The facilities and accommodation for the large numbers of passengers in the third class, or steerage as it was generally known, were very poor in the early days. But this voluminous emigrant traffic was a windfall for the ship owners. It was not long before intense competition developed between the various European ports of emigration, which included Hamburg (the Hamburg-Amerika Linie), Rotterdam (the Holland-America Line) and Liverpool (the White Star Line). All the shipping companies knew that the hundreds of steerage passengers, traveling in the ship's hold, largely determined their profits. Because of the continuing rise in demand the companies built ever-larger ships. It took many years of this competition before the very low standards began to improve. It was only in 1879 that oil lighting in ships was finally replaced with electricity. The Red Star liner Friesland, built in 1889, was the first ship to have electric lighting installed in the company fleet. Steel replaced iron in ship construction in 1880, and the first two ships to be built of steel were the Noordland and the Westernland.

Early in 1874 the Red Star Line began operating regular services from Antwerp to New York, in addition to the Philadelphia run. The advertised fare for one-way passage to either destination was $90 in first-class cabin, $60 in second-class cabin and $30 in third class. From the start the Red Star Line management tried to establish fast, dependable and, above all, regular service. That way, the Red Star Line hoped to satisfy the demand for shipping space and to capture a share of the large emigration traffic from Europe to North America—and obtain Belgian and United States mail contracts.

The American Line was sold in October 1884 to the International Navigation Company, which provided an established service from Philadelphia to Liverpool in addition to the existing Red Star Line's Antwerp run. The next important change in the history of the mother company came on June 6, 1893, when it was incorporated in New Jersey, and changed its title accordingly. It now had a capital stock of $15,000,000. The new, younger generation of owners was again connected with the Pennsylvania Railroad Company. They changed the

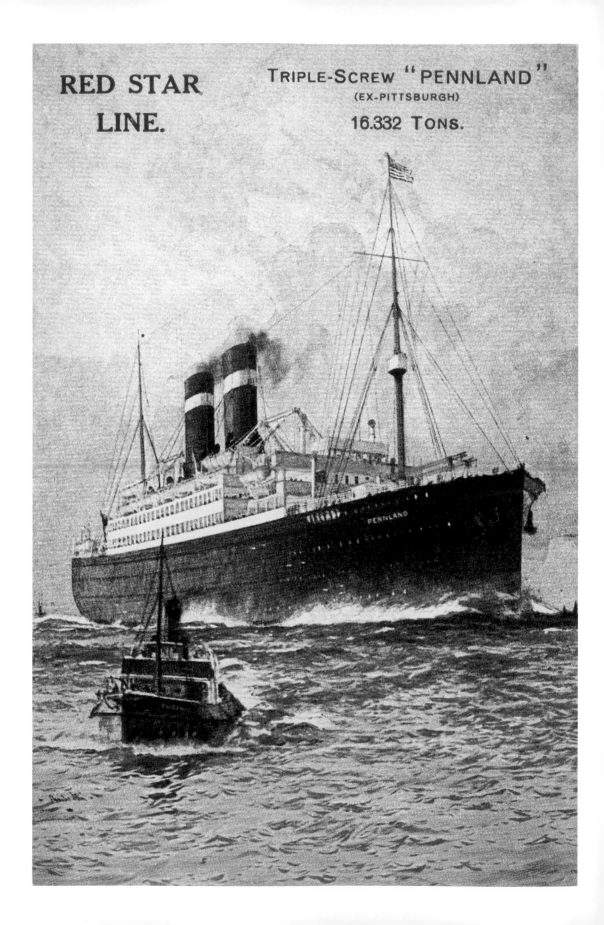

RED STAR
LINE.

TRIPLE-SCREW "PENNLAND"
(EX-PITTSBURGH)
16.332 TONS.

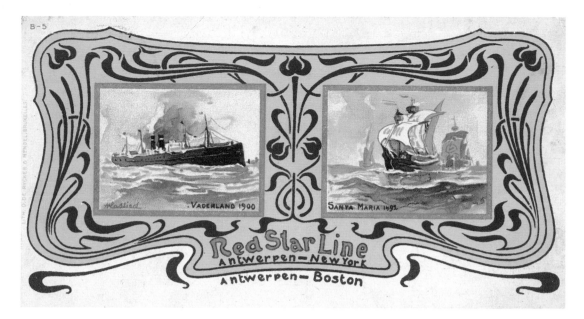

B-5

VADERLAND 1900 SANTA MARIA 1492

Red Star Line
Antwerpen—New York
Antwerpen—Boston

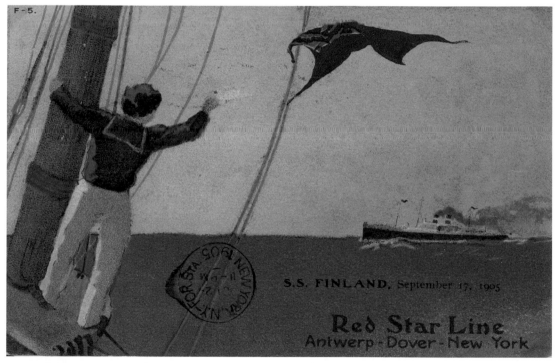

F-5.

S.S. FINLAND, September 17, 1905

Red Star Line
Antwerp-Dover-New York

T. S. S. „Kroonland"
Length 580 feet. Beam 60 feet.
Tonnage 12,185 gross.

Red Star Line
Antwerp-Dover-New York

terminal from Liverpool to Southampton, which provided easy access to Cherbourg and Le Havre and the substantial number of passengers to and from Paris, which these ports served. At the end of 1894 the ships' funnels were all standardized and now bore the combination of black with a white band. The International Navigation Company frequently interchanged the ships of the Red Star and the American Line, giving the operation an exceptional flexibility.

In 1881 the Red Star Line carried 1,521 cabin and 24,694 third-class, or steerage, passengers in 47 weekly voyages. In 1901 the totals were 6,241 in first and second-class, plus 32,793 steerage passengers in 52 voyages between Antwerp and New York, roughly equaling the numbers of the Holland-America and the French lines. In October 1902 the steamer Kensington of the American Line, running under charter for the Red Star Line between Antwerp and New York, crossed the Atlantic with one of her boilers fired exclusively by fuel oil instead of coal. It was the first time this had ever been tried in a trans-Atlantic passenger ship. This successful experiment was no doubt the first step in the ultimate conversion from coal to oil, a shift that took place in the coming years.

The International Mercantile Marine Company, the largest shipping trust in the world, with a capital stock of $120,000,000, was incorporated and chartered in New Jersey on October 1, 1902. This was the brainchild of the financial genius John Pierpont Morgan, who reorganized and renamed the International Navigation Company. It was Morgan and his wealthy partners who had merged several American railroad companies some years earlier. The new board of directors consisted of eight Americans and five Englishmen.

On the American side, and president of the new holding, was Clement A. Griscom, the expert on shipping. His English counterparts were a.o. two partners from the prestigious White Star Line (Oceanic Steam Navigation Co. Ltd. of Liverpool, acquired on February 4, 1902) and one from the Leyland Line (also 100 percent controlled). Control of the Holland-America Line was also indirectly obtained through a 51 percent share held by the Belfast shipbuilders Harland and Wolff Ltd. With all the previous and newly acquired shipping interests (a total of six) the I.M.M. Co. now controlled well-established passenger and freight services from New York, Philadelphia, Boston, Quebec City and Montreal to Liverpool, London, Rotterdam and Antwerp, with a fleet of 133 ships, totaling 9,952,110 gross tonnage. Attempts by J.P. Morgan to purchase the Cunard Line failed, due to the intervention of the British Government, which did not want to see the country's major shipping lines pass into the hands of the Americans.

The formation of the I.M.M. Co. had been accomplished in spite of significant flaws in its financial structure, particularly the acquisition of the White Star Line and many outdated ships at highly inflated prices, and the assumption of the outstanding heavy debts of the shipbuilders Harland & Wolff. There was also the issue of meeting the high overheads of all of these companies, each of which had retained its complete administration, dock installations, tenders in the various ports of call, and the numerous other facilities connected with a trans-Atlantic passenger and freight service. A shortage of working capital was another problem

About Antwerp and the Red Star Line
booklet cover, 1904
Antwerp, Van Mieghem Museum

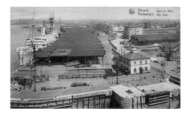

The Rijn Quay
postcard, ca. 1910
Antwerp, Van Mieghem Museum

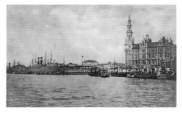

The Rijn Quay seen from the Scheldt
photograph, ca. 1923
Antwerp, Van Mieghem Museum

The Rijn Quay seen from the Scheldt
photograph, ca. 1904
Antwerp, Van Mieghem Museum

Red Star Line, postcard, ca. 1905
Antwerp, Van Mieghem Museum

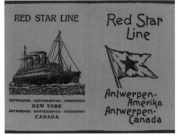
Travel wallet of the Red Star Line, ca. 1925
Antwerp, Van Mieghem Museum

Red Star Line, postcard, ca. 1900
Antwerp, Van Mieghem Museum

American warship on the river Scheldt
postcard, ca. 1900
Antwerp, Van Mieghem Museum

overleaf above: At the docks, ca. 1912
oil on panel, 30 x 41 cm
private collection

overleaf below: Emigrants at the Red Star
Line warehouse, ca. 1912
pastel and charcoal, 38 x 51 cm
private collection

that was resolved for a time by the financial support of J.P. Morgan. He died in 1913, no doubt knowing that the giant shipping trust he had created, with the intent of ruling the North Atlantic, would not attain the supremacy he had envisioned. In fact, less than fifteen years later the I.M.M. Co. liquidated its entire foreign flag shipping lines.

The I.M.M. Co., and the White Star Line in particular, suffered a severe blow on April 14, 1912, when the giant liner Titanic struck an iceberg on her maiden voyage from Southampton to New York. When she sank two hours and forty minutes later, 1,522 of the total of 2,227 passengers and crew members were lost. The Red Star Liner Lapland, which sailed from Antwerp on Saturday, April 6th, arrived in New York a few hours after the Titanic sank about 1,000 miles away in the Atlantic. Both ships were scheduled to leave New York on Saturday, April 20th, the Lapland at 10.00 am and the Titanic at noon. The Lapland sailed for Antwerp via Plymouth, instead of Dover, her usual port of call, taking with her surviving crewmembers of the Titanic, who had been brought to New York by the rescue ship Carpathia of the Cunard Line. Before the month of April was out, the I.M.M. Co.'s newspaper advertisements carried the special notice that, effective immediately, all their liners would be crossing the Atlantic on the Southern Track, outside the path of the icebergs on their journey from the Arctic Circle in the spring. This detour added about nine hours of time to the crossing.

The construction of the Belgenland II had been ordered in March 1912, and she was launched on December 31, 1914, from the shipyards of Harland & Wolff Ltd. in Belfast, the first liner built with a bulbous cruiser stern. She was temporarily completed in June 1917 as a cargo ship for the Ministry of War Transport, and was the largest in the world.

She lay idle for two years after the outbreak of World War I. Early in the war, when the port of Antwerp fell into German hands, the Red Star liners were transferred to British registry and the Red Ensign. The exceptions were the Kroonland and the Finland, which sailed under the American flag, as well as the Samland and Gothland, both under the Belgian flag. The latter two ships were eventually used for the Relief in Belgium shipments. The Lapland, after operating between Antwerp and New York since her maiden voyage on April 10, 1909, was placed under the management of the White Star Line. She was converted to a troopship running between Canada and Britain.

On April 17, 1917, eleven days after the United States entered the war, the Lapland struck a mine close to the Mersey Bar lightship at the end of a voyage from New York to Liverpool. The Kroonland, flying the American flag, escaped an attack by two German submarines while on a voyage from New York to Liverpool in May 1917. Since most of the company's steamers were capable of a service speed of at least 14 knots, they generally traveled in the faster convoys, and were therefore relatively difficult targets for enemy submarines. During the war the Belgenland II was placed under the management of the White Star Line, renamed the Belgic and was put into service between New York and Liverpool.

With the United States now in the war, the Belgic was in New York and outfitted as a troopship with the capability of carrying three battalions at

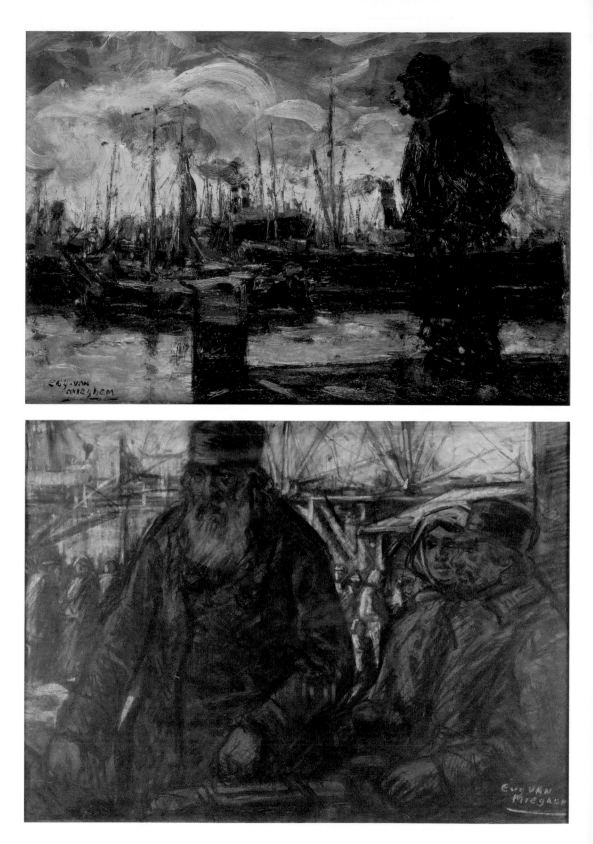

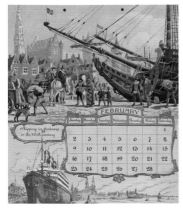

Red Star Line calendar February 1925
Antwerp, Van Mieghem Museum

Red Star Line calendar March 1925
Antwerp, Van Mieghem Museum

Red Star Line calendar cover, 1925
Antwerp, Van Mieghem Museum

a time across the Atlantic. With Holland a neutral country in the First World War, the Holland-America Line was in a strong financial position early in 1915 to purchase the shares in their company held by the Norddeutscher Lloyd and the Hamburg-Amerika Linie. Two years later the shares held by the I.M.M. Co. were also acquired, at which time the famous Dutch line had regained full ownership and control.

The years 1920 and 1921 were a time of mass emigration from Eastern Europe to the United States. Every shipping company was clamoring for a big piece of this business, until the Dillington Act, which took effect in May 1921, set quotas and reduced immigration to less than half its previous numbers. The Belgic continued to operate as a cargo liner until the spring of 1921, when she was withdrawn from service. In March 1922 the ship was returned to Harland & Wolff for completion of its originally planned construction, of two upper decks and three funnels (one of which was decorative) instead of two.

The ship was renamed Belgenland and officially launched for her maiden voyage for the Red Star Line on April 4, 1923. As the Red Star Line flagship and the world's eighth largest liner, she could accommodate 500 passengers in first class, 600 in second and 1,500 in third class. However, because of the new severe restrictions on immigration the number of steerage passengers never exceeded one thousand. The interior was very similar to that of her sister ships built by the same yard, the Titanic and the Olympic.

On January 19, 1924, she sailed from New York on a cruise to the Mediterranean that lasted 67 days, until March 24. The famous travel experts, Thomas Cook & Sons, chartered her. On her return in early April, the Belgenland, along with the Lapland, was diverted from Antwerp to London because the deep navigation channels of the river Scheldt had sanded-up to such a high level.

On December 4, 1924, when the Belgenland sailed from New York on her first world cruise, she was carrying 461 passengers and 613 crewmembers on board. On December 12th, she set the record for being the largest liner ever to pass through the Panama Canal. She was also the largest ever to circumnavigate the globe, a voyage that lasted 133 days, covered 28,310 miles, and involved 60 cities in 124 countries. The passengers on this first world cruise paid a total of over $2,000,000. The most expensive suites cost $40,000 for six people and $25,000 for four.

In 1925 the Red Star Line bought the Pennland from the White Star Line to run between Antwerp and New York. But the financial position of the mother company was deteriorating. The most important asset of the I.M.M. Company, the White Star Line, was bought by the Royal Mail Steam Packet Company of Britain on January 1, 1927. The International Navigation Co. of Liverpool (created to bring the American Line under British registry and flag) was liquidated in 1930 and taken over by one of its subsidiaries, Frederick Leyland & Co. Ltd. of Liverpool.

The Red Star Line came under the direct control of this company. At the end of 1933 the I.M.M. Company fleet was reduced to 19 ships and to 11 ships by the end of 1935. The dream was over. The liquidation of

the Red Star Line began with the transfer of the Kroonland and Finland to the American Line in 1923. In 1927, after a total of 25 years of service, they were both sent (by the new owner, the Panama Pacific Line) to the breakers' yards.

The Gothland was sold for scrap at the end of 1925; she had served 16 years for the Red Star Line and 16 years for the White Star Line (renamed the Gothic). This was followed in 1927 by the transfer of the Zeeland to the Atlantic Transport Line of London, where she was renamed the Minnesota; she was finally scrapped in 1930. In 1929 the Red Star Line bought the Westernland from the White Star Line. In 1931, after 23 years of service, the Samland was scrapped. The Lapland made her last trans-Atlantic voyage in June 1932. Apart from her wartime service, she had been a cruise ship since 1923. In 1930 she sailed between New York, Havana and Bermuda. In 1933, after a career of 24 years, she was scrapped in Japan. The Westernland sailed from New York for the last time on December 12, 1934. She arrived in Antwerp on December 22nd.

The most passengers the Belgenland ever carried was 1,657 on a day trip out of New York without any specific destination, on October 12, 1931, in celebration of Columbus Day. The purpose of this trip was to sail outside the twelve-mile territorial limit, at which point all the ship's bars would be opened. By 1931 several newer and more luxurious liners were now circumnavigating the globe, and the Belgenland was no longer competitive.

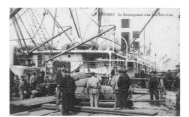

The unloading of a Red Star Line vessel
postcard, ca. 1910
Antwerp, Van Mieghem Museum

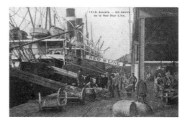

A vessel of the Red Star Line
postcard, ca. 1905
Antwerp, Van Mieghem Museum

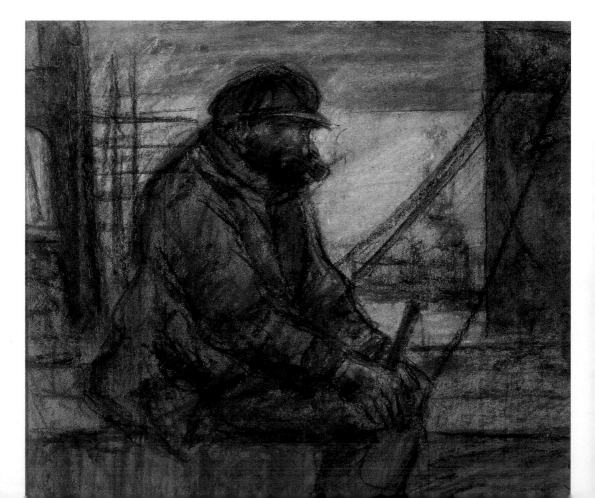

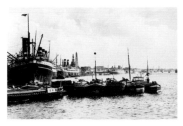

A view of Antwerp
photograph, ca. 1923
Antwerp, City Archives

left below:
An emigrant on the Rijn Quay, ca. 1910
pastel, 31 x 40.5 cm
Antwerp, National Maritime Museum

The departure of the Belgenland, ca. 1925
oil on board, 39 x 49 cm
private collection

In 1934, when no buyer could be found, she was renovated in Tilbury after her last Mediterranean cruise. On December 18, 1934 she was transferred from British to American registry and renamed the Columbia. She restarted cruise activity between New York and Nassau, Miami and Havana. The last of these cruises landed in New York on April 10, 1935 with only 285 passengers on board! On March 26, 1936, the Columbia was sold for scrap to a Scottish firm for $275,000.

The staff of the Red Star Line who worked in Antwerp were given dismissal notices effective December 31, 1934, marking the end of the famous line, after 62 years in operation. The dissolution of the Red Star Line was announced on March 10, 1935, in a Belgian government publication, which stated that, on February 27, 1935, a meeting of shareholders in Antwerp had voted to dissolve the present company.

The sole function of the new company to be left would be as temporary liquidators of all the Red Star Line assets remaining in January 1935. The firm consisted of seven Belgian shareholders, with a total of 200 shares of 5,000 Belgian francs ($100 each). The majority shareholder was Mr. Eric Sasse, who was prominent in maritime and commercial Antwerp. In February the Pennland and the Westernland were sold to Arnold Bernstein Reederei of Hamburg for $1,000,000. The sale of these two liners to German interests (under which they flew the swastika) evoked resentment in British government and shipping circles. Both ships

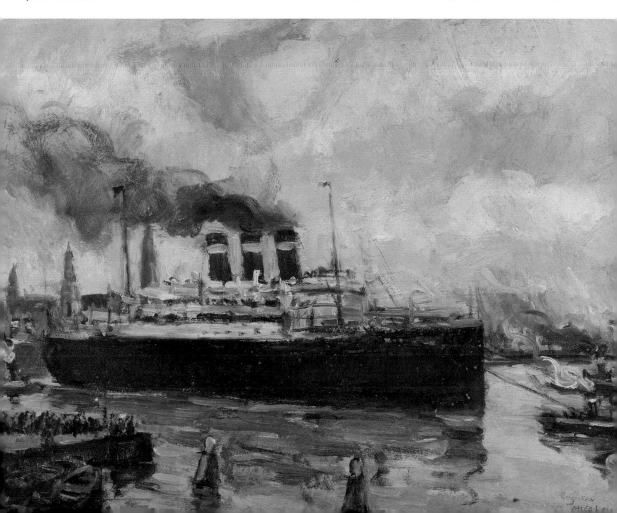

underwent renovations at Kiel and were adapted for the transport of uncrated cars, and were able to accommodate 486 exclusively tourist class passengers.

Because the I.M.M. Co. had an operating loss in 1934 of $2.1 million and its overseas subsidiaries had capital losses of $8,000,000, the company could not afford to be selective about prospective buyers... In April 1938 the Pennland and Westernland were bought by the Holland-America Line and the two ships continued the Antwerp-New York tourist class service, with the German swastika now replaced by the Dutch tricolor. When the Germans invaded Holland and Belgium on May 10, 1940, the two liners were out of the war zone. Both were used in the war as troop ships.

The Westernland was even chosen by General de Gaulle as his flagship in his attempt to take control of Dakar (the capital of Senegal in Africa). In April 1941 the Pennland, under heavy attack by German Junker-88 dive bombers, sank 25 miles off the Greek island of Kea. The Westernland was scrapped in 1947.

R.S.L. postcard, ca. 1902
Antwerp, Van Mieghem Museum

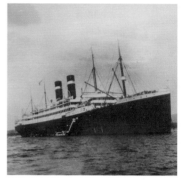

The Lapland, photograph, ca. 1927
Antwerp, Van Mieghem Museum

Antwerp, Gateway to the New World: "One Foot in America!"

With its efficient network of Eastern European agents and competitive prices, the Red Star Line succeeded in transporting about three million emigrants up until 1935. Many emigrants would arrive in Antwerp after having traveled for weeks. It was often a journey lasting several weeks for the emigrants from their home countries to Antwerp's Rijn Quay, where the ships of the Red Star Line were moored. Before embarkation the emigrants had to undergo a medical examination to ensure that they were sufficiently healthy so as not to be sent back from the U.S. by the American immigration authorities – at the cost of the shipping line.

In 1893 the Red Star Line opened a warehouse on the corner of Rijn Quay and Montevideo Street where the medical examinations were conducted, and clothing and luggage disinfected. The emigrants passed their last days before departure in guesthouses that offered little comfort or hygiene. Typically, the journey from Antwerp to New York by steamship took anywhere from seven to fourteen days. For the steerage passengers, traveling outside on the deck or inside in the stuffy hold, it was a grueling ordeal. The food was unpalatable, the drinking water often impure, and many became seasick.

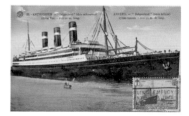

The Belgenland
postcard, ca. 1924
Antwerp, Van Mieghem Museum

Emigrants were motivated by a variety of forces: economic necessity, the longing for freedom, a sense of adventure, the lure of fortune and ambition. The Jewish emigrants from eastern Europe and Russia were driven chiefly by chronic poverty and unemployment, as well as continual oppression and persecution. Massive emigration followed the 1881 murder of the liberal Tsar Alexander II (1855-1881), who had introduced important reforms in Russia that improved the position of Jews living in the Pale of Settlement, that area of Russia where the Jews were legally authorized to settle.

The Pale covered an area of about 386,000 square miles and stretched from the Baltic Sea to the Black Sea. By 1897, just under 4,900,000 Jews

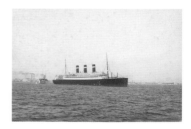

The Belgenland at sea, photograph, ca. 1925
Antwerp, Van Mieghem Museum

The Red Star Line buildings
photograph, ca. 1920
Antwerp, City Archives

Interior of the Red Star Line building
photograph, ca. 1920
Antwerp, City Archives

Interior of the Red Star Line building
photograph, ca. 1920
Antwerp, City Archives

Interior of the Red Star Line building
photograph, ca. 1920
Antwerp, City Archives

lived there, comprising 94 percent of the total Jewish population of Russia and about 12 percent of the population of the area. The successors of Alexander II revived, and even intensified, the traditional anti-Semitic policy of former tsars. The authorities incited among the Russian people an old and profound dislike of Jews, blaming the Jews for all the social and economic problems plaguing the Russian empire. Pogroms were widespread, even in the cities of Kiev, Odessa and Warsaw – all of which had large Jewish communities.

The first major exodus began the summer of 1881, when thousands of refugees, in flight from pogroms that had spread across the whole of Ukraine, poured into the city of Brody. Starving and homeless, these Jewish refugees were sometimes forced to sleep on the streets, and suffered unanticipated harsh treated by the Austrian authorities. These refugees presented a huge problem that extended beyond the Jewish community of Brody, which was obviously unable to care for them.

Even in their wretchedness, the Eastern European Jews were proud, and had harsh words for their more prosperous Western European brothers. Still, the Western European Jewish communities, through such agencies as the Baron de Hirsch Fund and the Alliance Israélite Universelle, did help. Relief poured into Brody, refugees were able to travel to Hamburg and Bremen, and quarters—albeit miserable—were set up in the ports. In Paris a committee headed by the writer Victor Hugo organized a public protest against the pogrom, and liberal newspapers sold subscriptions to aid the refugees. In the spring of 1882, after renewed pogroms in Russia, fresh streams of victims poured into Brody, which had now become a magnet for all the helpless who had heard of the relief and emigration depots there. Over the next few years, especially after 1900, permanent agencies, such as the Hilfsverein der Deutschen Juden, were created to help the east Europeans on their way. These agencies established information bureaus to help the travelers, and they negotiated special rates with railway companies and steamship lines. They also instituted precautions against the ever-present scoundrels who tried to fleece the emigrants and negotiated with governments to ease the journeys.

During the 1870s and the 1880s the general feeling in America was receptive to immigration, though the Jewish community tended to favor a mildly restrictive approach. That the Jews in America should respond at first with anxiety is understandable. But in 1891 Dr. Julius Goldman, representing the United Hebrew Charities, declared America the best destination for the Russian-Jewish refugees.

By the early 1900s the American Jewish leaders (the majority of German origin) had not only organized effective relief in the larger American cities but also were engaged in the subterranean struggle against efforts to restrict immigration. Led by such figures as Jacob Schiff and Louis Marshall, they devoted their sense of solidarity, their moderate but firm liberal principles, and their growing ease in America to the cause of supporting the masses of Jews pouring in from eastern Europe.

The bloody pogroms that were carried out in 1903 in Kishinev, capital of Bessarabia (now Chisinau in Moldavia), in which forty-nine people

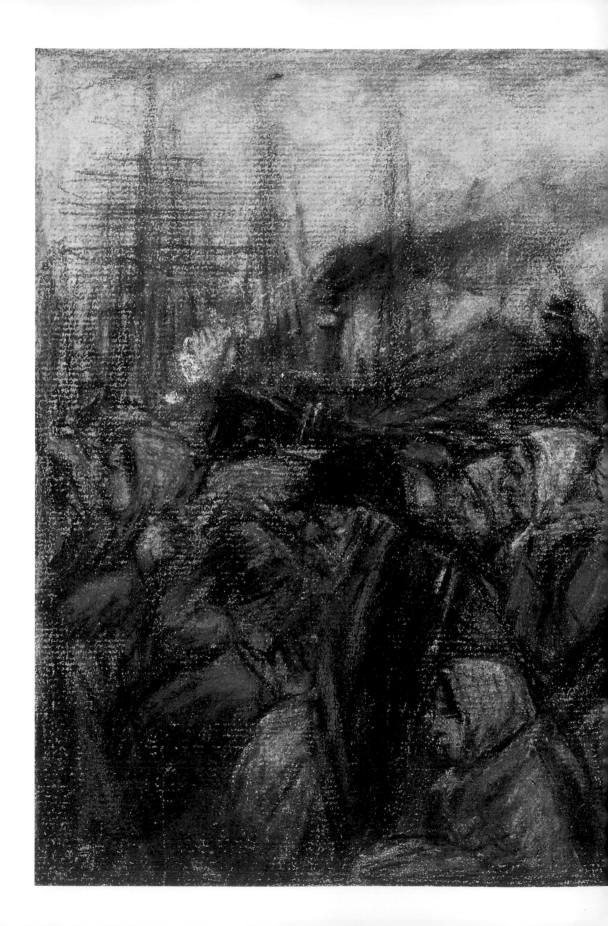

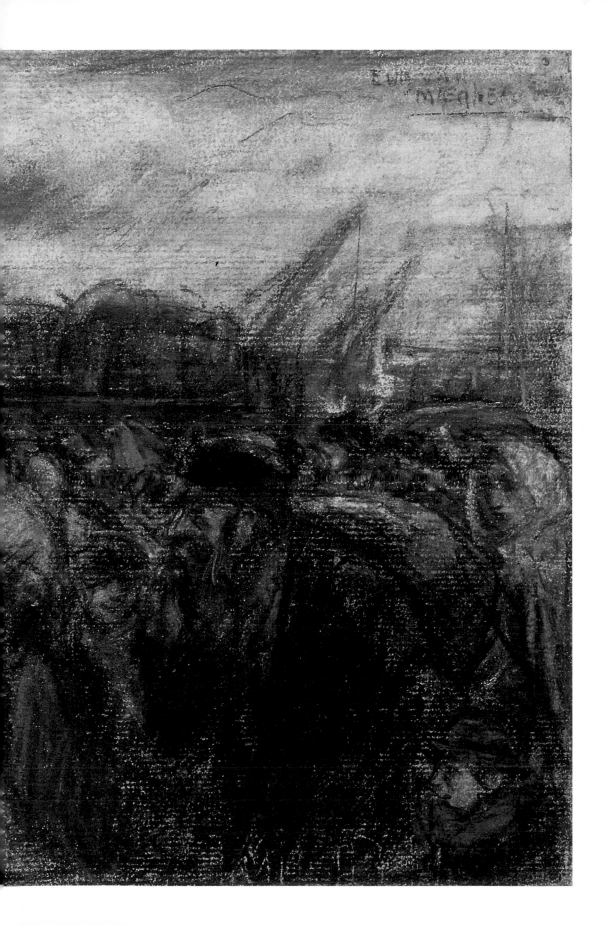

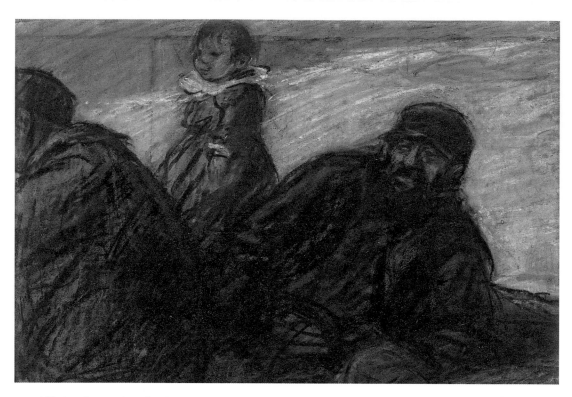

were killed and more than five hundred injured, caused panic among the Eastern European Jewish communities and led to large-scale emigration.

Further pogroms triggered by the failed People's Revolution of 1905 contributed to the emigration to America of about one-third of the Jewish population of eastern Europe and Russia – almost two million people - between 1881 and the outbreak of the First World War in 1914. Jews from the Ukraine and Southern Russia usually crossed the Austro-Hungarian border illegally before traveling by train to Vienna or Berlin and then regrouping for the journey to one of the major ports of embarkation: Hamburg or Bremen (Germany), Rotterdam or Amsterdam (Holland) and Antwerp (Belgium).

For those without legal passports, the first major crisis of the journey was the border crossing into Austria or Germany. Bands of smugglers, increasingly expert, preyed on the fears of the emigrants. Abraham Cahan's account of his 1882 crossing of the Austrian border is classic: "We were to leave the train at Dubno where we were to take a wagon through the region around Radzivil on our way to the Austrian border. That would be our last city in Russia; across the border was Brody.

In the evening we followed two young Ukrainian peasants to a small, freshly plastered hut. One of the peasants was tall and barefooted and carried a small cask at his side. In Austria, there was no tax on brandy, so he smuggled it into Russia; on his return trip, he carried tobacco, more expensive in Austria. We waited a long time in the hut before realizing we were being held for more money. Having paid, we moved on. We made a

Third class (steerage), photograph, ca. 1900
Antwerp, City Archives

Red Star Line agency in Eastern Europe
photograph, ca. 1910
Antwerp, Van Mieghem Museum

Emigrants waiting in the
Montevideostraat, 1899
pastel, 23 x 35 cm
private collection

strange group going across fields and meadows in the night, halted suddenly every few minutes by the tall peasant holding up his finger and pausing to listen for God-knows-what disaster..."

But discomfort, hunger and humiliation were nothing compared to the abject terror gripping all emigrants: that they, or one of their family, might be sent back or kept off the boat after the dockside inspection. In his book "*Mottel: The Cantor's Son*", Sholom Aleichem describes a family waiting in Antwerp to leave with the Red Star Line: " ...People tell them that they should take a walk to the doctor. So they go to the doctor.

The doctor examines them and finds they are all hale and hearty and can go to America, but she, Goldele, cannot go, because she has trachomas on her eyes. At first her family did not understand. Only later did they realize it. That meant they could all go to America but she, Goldele, would have to remain here in Antwerp. So there begins a wailing, weeping, a moaning. Three times her mama fainted. Her papa wanted to stay here, but he couldn't. All the ship tickets would be lost. So they had to go off to America and leave her, Goldele, here until the trachomas would go away from her eyes... "

He went on: " ...No other city was I so sorry to leave as Antwerp. Not so much the city, as the people. And not so much the people as the gang of emigrants. And not so much the gang, either as my friends. Many have already gone. Vashti, Alteh, and Big Mottel are in America by this time making a living..."

Some of those leaving in the mass of emigrants went on to become famous Americans, including Irving Berlin, Albert Einstein and the

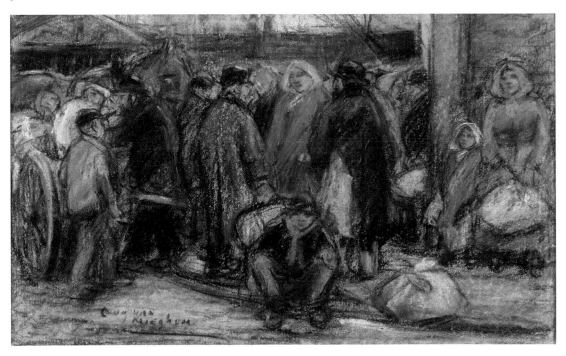

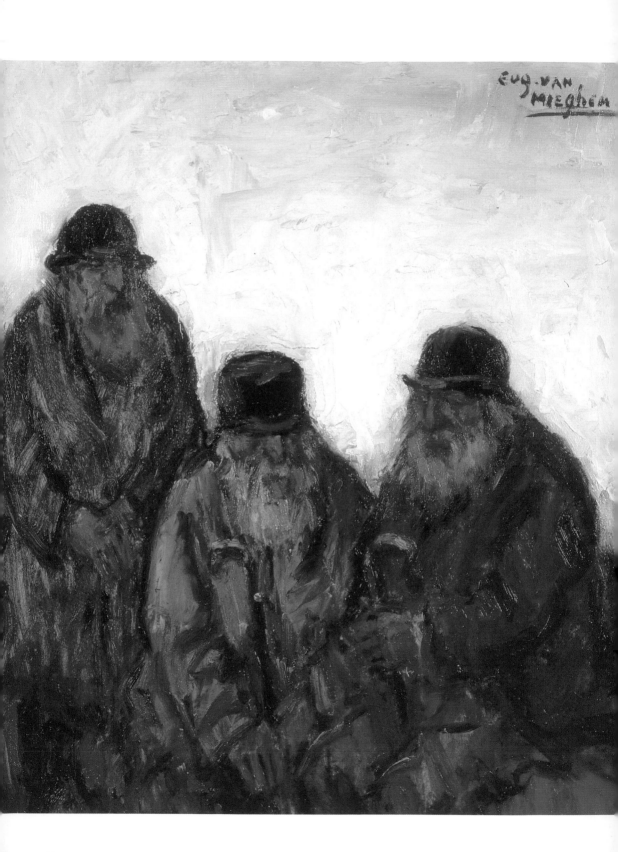

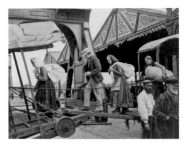

Emigrants on the gangway
photograph, ca. 1912
Antwerp, City Archives

writer Yuri Suhl, who wrote in his memoir: " ...I don't remember exactly what the weather was like during those days, so I'll skip that. But I remember a few other things and remember them well. When we arrived in Antwerp my father heaved a deep sigh and said, "Now, thank God, we are with one foot in America already. Next stop is New York."

At Antwerp the emigrants were herded into a huge dormitory where they ate, slept, and waited for their boats. Their baggage consisted of straw baskets, rusty trunks, and pillowcases stuffed with their most cherished belongings. It also served as tables, chairs, and beds. The sharp smells of onion, herring, salami, and moldy bread mingled with the strong odors of sweaty, unwashed bodies, dirty socks, and tobacco smoke, and fused into a thin vapor that rose to the ceiling and made the walls perspire. Most of the emigrants slept with their clothes on, and I liked the idea of not having to dress in the morning. Each night my father would cover me with his old fur-lined coat, and long after the lights went out I would lie awake listening to the weird sounds of the snorers...

The immigrants grouped themselves according to their nationalities, and since the Jews made up the bulk of the passengers, they occupied half of the dormitory; the other half was divided among the Poles, Czechs, Germans, and Romanians..." (Excerpt from *"One Foot in America"*).

Tired emigrant, 1901
black chalk, 16.5 x 11 cm
private collection

left:
Jewish emigrants waiting for a vessel, 1904
oil on panel, 47 x 39 cm
private collection

right:
Jewish emigrants arriving in Manhattan
photograph, ca. 1904

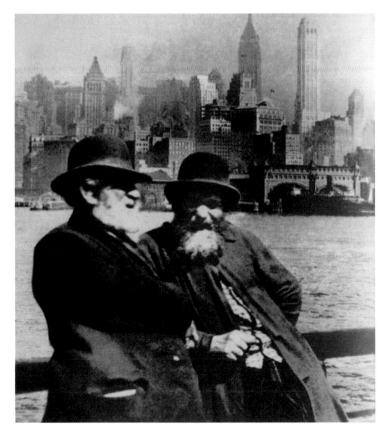

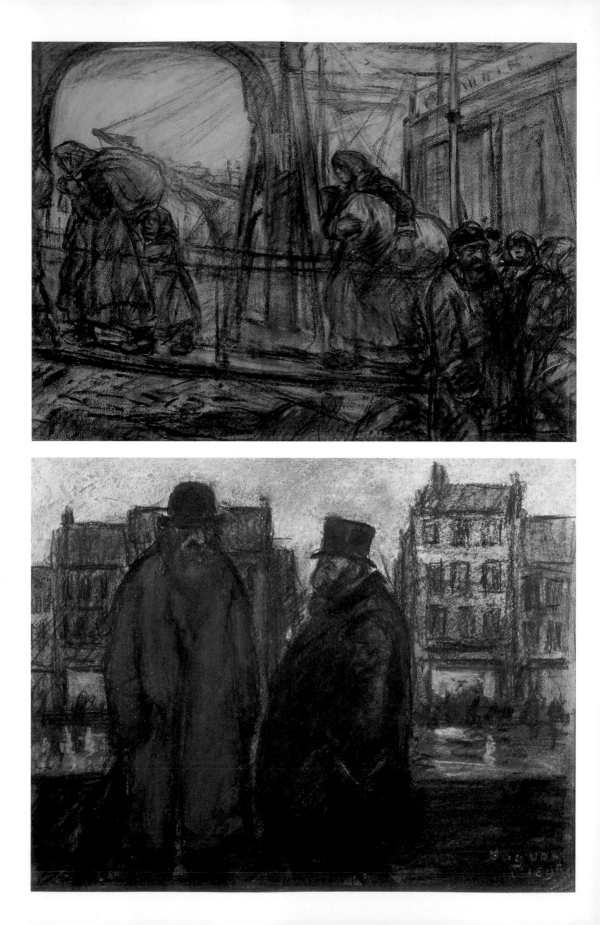

Antwerp today has an important Jewish community. Just as the Sephardic Jews were major economic players during Antwerp's Golden Age, it was mainly Ashkenazi Jews who made Antwerp the diamond capitol of the world centuries later. The multicultural city of Antwerp, with its concentration of Hasidic Jews, is today sometimes regarded as the last shtetl in modern Europe.

The Ordeal of Steerage

Was the Atlantic crossing really as dreadful as legend has it? Was the food as awful, the treatment as harsh, and the steerage as disease-ridden? Of the hundreds of published and unpublished accounts emigrants have left, the overwhelming majority still express a shudder of dismay when they recall the journey by sea and the disembarkation at Castle Garden or Ellis Island. By the time they crossed the Atlantic, many emigrants had been reduced to a state of helpless passivity, unable to discern what was happening to them or why.

An acute description of this experience has been provided by Oscar Handlin: " ...The crossing involved a startling reversal of roles, a radical shift in attitudes. The qualities that were desirable in the good peasant were not those conductive to success in the transition. Neighborliness, obedience, respect, and status were valueless among the masses that struggled for space on the way. They succeeded who put aside the old preconceptions, pushed in, and took care of themselves...

Thus uprooted, they found themselves in a prolonged state of crisis... As a result they reached their new homes exhausted - worn out physically by lack of rest, by poor food, by the constant strain of close, cramped quarters, worn out emotionally by the succession of new situations that had crowded in upon them. At the end was only the dead weariness of an excess of novel sensations... "

The Jewish emigrant Morris Raphael Cohen, who traveled on the German ship Darmstadt, wrote: " ...We were huddled together in the steerage literally like cattle - my mother, my sister and I sleeping in the

Emigrant, 26 January 1904
black chalk, 15.6 x 10.7 cm
private collection

Albert Einstein leaving Antwerp on the
Red Star Line, photograph, ca. 1929
private collection

Emigrants waiting in the
Montevideostraat, 1902
pastel, 18 x 42 cm
private collection

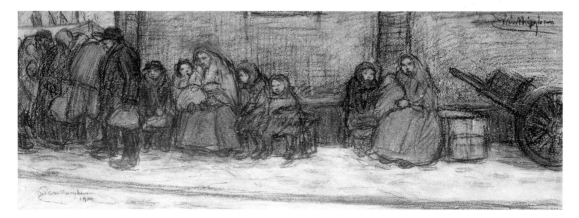

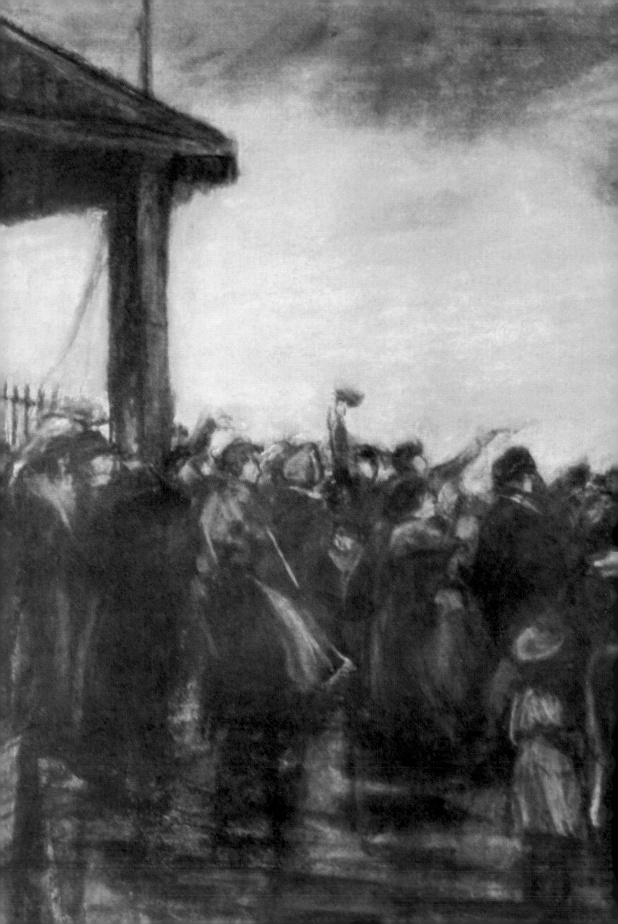

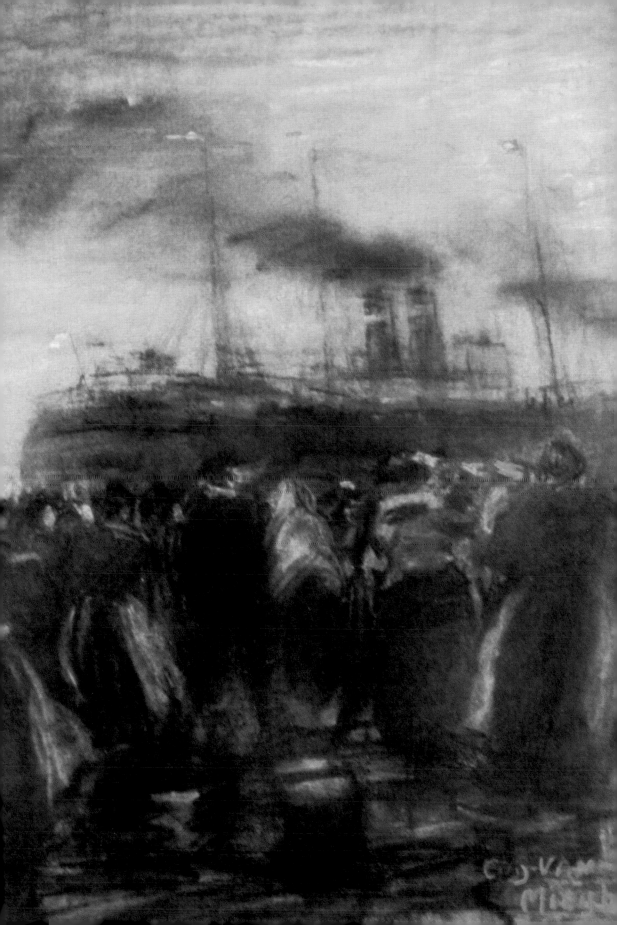

middle tier, people being above us and below us.... We could not eat the food of the ship, since it was not kosher. We only asked for hot water into which my mother used to put a little brandy and sugar to give it taste.

Towards the end of the fourteen-day trip when our bread was beginning to give out we applied to the ship's steward for bread, but the kind he gave us was unbearable soggy... More than the physical hardships, my imagination was occupied with the terrors of ships colliding, especially when the foghorn blew its plaintive note... One morning we saw a ship passing at what seemed to me a considerable distance, but our neighbor said that we were lucky, that at night we escaped a crash only by a hair's breadth..."

Here is a passage from an unpublished memoir by a barely literate woman writing in Yiddish after her arrival in 1891: " ...The sky was blue - the stars shining. But in my heart it was dark when I went up on the ship... We rode three weeks on a freight train so I had plenty of time to think things over. My future... where am I going? ...to whom? what will I do? In Grodno I was at least someone in the store. But in America, without language, with only a bit of education... Young people laughed and joked even though in my heart it was like the storm at sea... And then a real storm broke out. The ship heaved and turned. People threw up, dishes fell, woman screamed... but in my heart I didn't care what happened..."

In all such recollections, the force of trauma overcomes the force of personality and cultivation. To the extent that steerage imposed a deadening effect, the reactions among people are virtually the same, whether they were illiterate or intellectuals.

In 1906, an Iowa clergyman named Edward Steiner wrote a book called *"On the Trail of the Immigrant"*: "...The steerage never changes, neither its location nor its furnishings. It lies over the stirring screws, sleeps to the staccato of trembling steel railings and hawsers. Narrow, steep and slippery stairways lead to it. Crowds everywhere, ill smelling bunks, uninviting washrooms - this is steerage. The odors of scattered orange peelings, tobacco, garlic and disinfectants meeting but not blending. No lounge or chairs, for comfort, and a continual Babel of tongues - this is steerage. The steamship company deals the food, which is miserable, out of huge kettles into the dinner pails provided. When it is distributed, the stronger push and crowd... On many ships, even drinking water is grudgingly given, and on the steamship Staatendam we had literally to steal water for the steerage from the second cabin, and that of course at night. On many journeys, particularly on the Fürst Bismarck the bread was absolutely uneatable, and was thrown into the water by irate emigrants... "

Ellis Island: The Isle of Hope and Tears

"The day of the emigrants' arrival in New York was the nearest earthly likeness to the final Day of Judgment, when we have to prove our fitness to enter Heaven".

Carla Kamphuis-Meijer, The emigrant 2005, (after the drawing by Eugeen Van Mieghem)
bronze, 29 cm high
signed and numbered 2/100
New York, South Street Seaport Museum

Emigrant, 26 January 1904
black chalk, 15.6 x 10.7 cm
private collection

previous page:
The departure, 1902
pastel, 44 x 63.5 cm
private collection

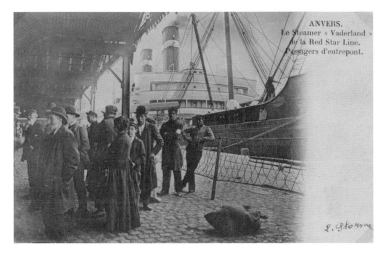

Emigrant with an umbrella, 1902
black chalk, 20.4 x 12.9 cm
private collection

These were the words of a sympathetic journalist of the early twentieth century writing about the immigrant experience. Nothing, not even the difficulties endured en route to America, roused such overflowing anxiety, even self-destructive panic, as the test of Ellis Island. In order to cope with the huge numbers of passengers streaming off the ships, several buildings were constructed on Ellis Island (near the Statue of Liberty) where the immigrants were registered. More than two thousand people passed through Ellis Island on January 1, 1892, its first day of operation.

Over forty organizations had their representatives on Ellis Island, ready to offer assistance to the immigrants. During the busiest years, from 1892 to 1924, thousands would arrive each day. Before disembarking, the immigrants were essentially sorted; they were numbered and lettered by group, corresponding to entries on the ship's manifest, and then herded onto the Customs Wharf. On Ellis Island they piled into the massive hall that occupies the entire width of the building. There they were directed to break into dozens of lines, divided by metal railings, leading to the first doctor. Men whose breathing was heavy, women who were trying to hide a limp or deformity behind a large bundle were marked with chalk: H for heart, K for hernia, Sc for scalp, X for mental defects. One of every six people was sent for further medical examination.

Emigrants in the Montevideostraat, 1902
pastel, 16.5 x 37.5 cm
private collection

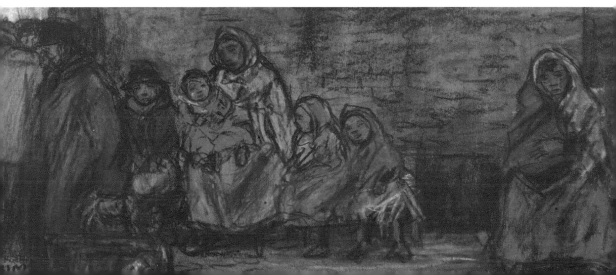

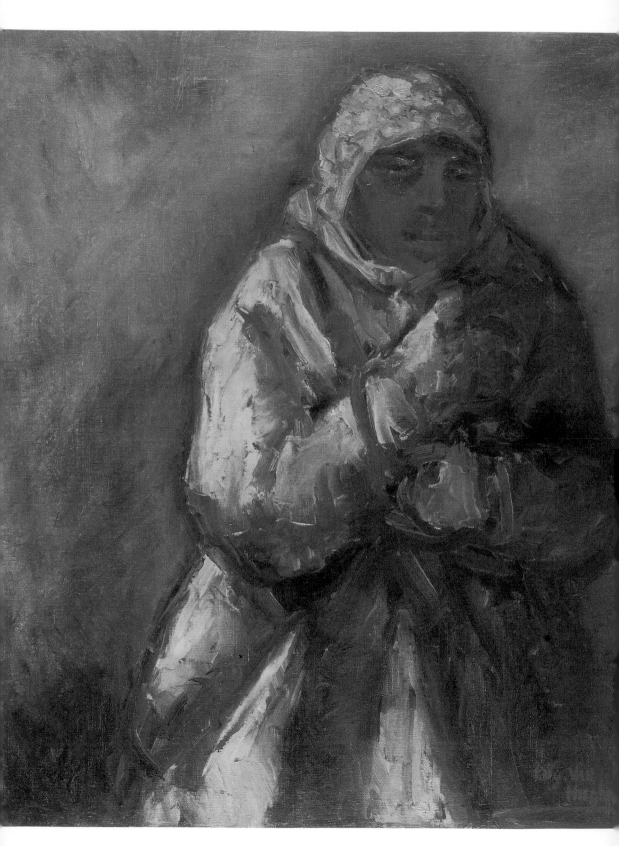

The Lapland
postcard, ca. 1912
Antwerp, Van Mieghem Museum

left:
Female emigrant, ca. 1925
oil on canvas, 64.5 x 54 cm
private collection

First-class cabin interior of the Lapland
photograph, ca. 1912
Antwerp, Van Mieghem Museum

Steerage, or third-class, passengers faced a particularly stringent process before being allowed to enter the U.S. In spite of undergoing strict medical examinations before setting off for America, two per cent of the immigrants were refused entry. People were denied if they were suffering from any kind of physical ailment, such as an eye inflammation or a skin infection, but also if they were suspected of criminal behavior or mental illness. Except for those times when the number of immigrants was so high as to overwhelm the Ellis Island staff, the average person passed through Ellis Island in about a day. Ferries ran twenty-four hours a day between the island and both the Battery and points in New Jersey. Those unfortunate enough to be detained for medical or other reasons usually had to stay on Ellis Island for one or two weeks.

The standard defense of the procedures adopted at Ellis Island was offered by H. P. Fairchild, an influential historian of immigration: "...During the year 1907 five thousand was fixed as the maximum number of immigrants who could be examined at Ellis Island in one day; yet during the spring of that year more than fifteen thousand immigrants arrived at the port of New York in a single day. As to the physical handling of the immigrants, this is caused by the need for haste...

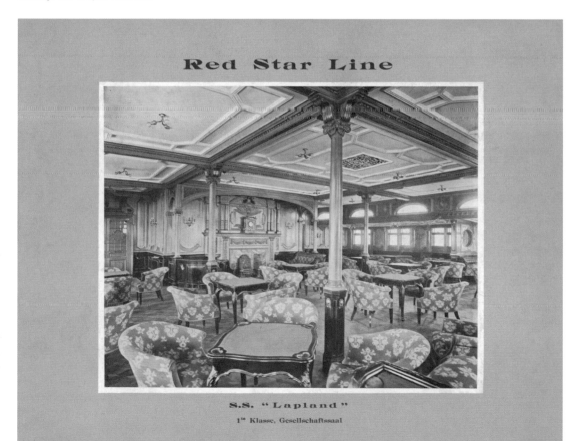

Red Star Line

S.S. "Lapland"
1ᵉ Klasse, Gesellschaftssaal

Smoking room of the Lapland
photograph, ca. 1912
Antwerp, Van Mieghem Museum

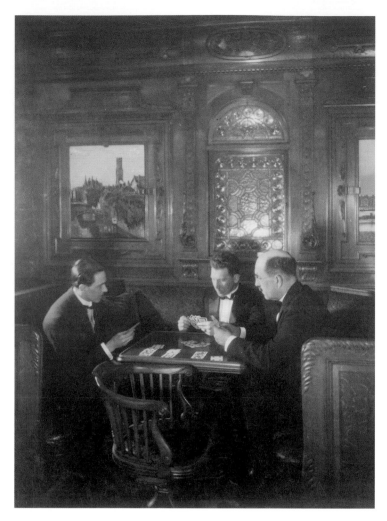

Second-class cabin interior of the Lapland
photograph, ca. 1912
Antwerp, Van Mieghem Museum

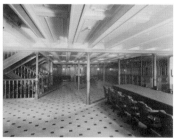
Second-class bedroom of the Lapland
photograph, ca. 1912
Antwerp, Van Mieghem Museum

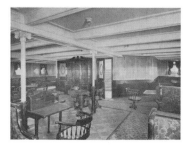
Second-class cabin interior of the Lapland
photograph, ca. 1912
Antwerp, Van Mieghem Museum

The conditions of the voyage are not calculated to land the immigrant in an alert and clear-headed state. The bustle, confusion, rush and size of Ellis Island complete the work, and leave the average alien in a state of stupor... He is in no condition to understand a carefully worded explanation of what he must do, or why he must do it, even if the inspector had the time to give it. The one suggestion, which is immediately comprehensible to him, is a pull or a push; if this is not administered with actual violence, there is no unkindness in it... "

In the 1860s and the 1870s, when the American railroads were in need of cheap labor and the western and southern states were eager to absorb white settlers, American business interests sent special agents to Europe in order to attract immigrants. There was still widespread faith in the idea of America as a refuge from tyranny and a country where fixed class lines gradually softened or disappeared. Historians of immigration have distinguished, with rough usefulness, between "old" and "new" immigrants, the former mostly from northern and the latter from southern and eastern Europe. Close in cultural style to the Protestant Americans, the old

Reading room of the Lapland
photograph, ca. 1912
Antwerp, Van Mieghem Museum

Dinner menu, S.S. Vaderland
17 April 1905
Antwerp, Van Mieghem Museum

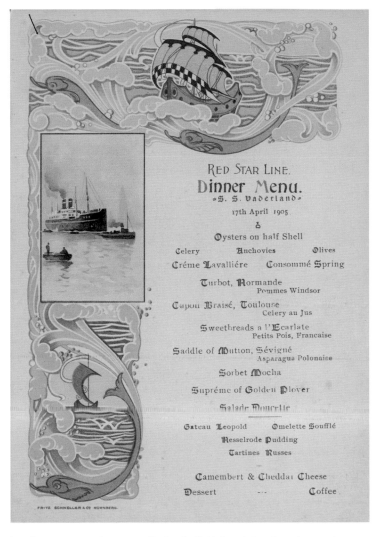

RED STAR LINE.
Dinner Menu.
=S. S. Vaderland=
17th April 1905

Oysters on half Shell

Celery Anchovies Olives

Créme Lavalliére Consommé Spring

Turbot, Normande
Pommes Windsor

Capon Braisé, Toulouse
Celery au Jus

Sweetbreads a l'Ecarlate
Petits Pois, Francaise

Saddle of Mutton, Sévigné
Asparagus Polonaise

Sorbet Mocha

Supréme of Golden Plover

Salade Mourette

Gateau Leopold Omelette Soufflé
Nesselrode Pudding
Tartines Russes

Camembert & Cheddar Cheese
Dessert --- Coffee

FRITZ SCHNELLER & Cº NÜRNBERG.

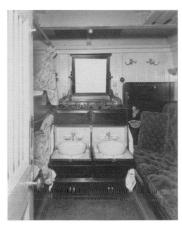

Second-class stateroom, photograph, ca. 1912
Antwerp, Van Mieghem Museum

Breakfast menu, S.S. Westernland
11 October 1905
Antwerp, Van Mieghem Museum

immigrants seemed more easily "assimilable" and thus less threatening than the new. By the 1880s and 1890s the mass influx consisted largely of new immigrants: poorly educated and often illiterate peasants whose manner was potentially unnerving to the native population.

The social movement known as nativism, which targeted the "immigrant hordes", emerged in America during the 1880s. Basically a form of xenophobia, the nativist movement was stoked by the fear of radicalism that swept America during the late 1880s, in part as a result of the Haymarket Affair of 1886. Six immigrants were charged and sentenced to death for setting a bomb explosion at an anarchist rally in Chicago, and fierce labor struggles across the country were attributed to foreign agitators. After the First World War the attitude of the American government towards immigration changed drastically. In 1921 the American Congress passed a new immigration law with a quota system that limited the number of immigrants admitted from each country.

On November 29, 1954, the federal government closed Ellis Island. After falling into neglect, the buildings of Ellis Island underwent a long period of renovation and reopened as the Ellis Island Immigration Museum on September 10, 1990. In 1999 the emigrant drawings by Eugeen Van Mieghem were exhibited in the Ellis Island Dormitory Galleries. Today Ellis Island is celebrated as the "Golden Door" to America for the 12 million immigrants who first set foot on American soil there between 1892 and 1924. Overall, 90 percent of the immigrants who passed through Ellis Island were Europeans—a marker of the importance of Ellis Island in European history. Forty percent of the American population can trace their ancestry to those brave and determined individuals who first entered the country via Ellis Island.

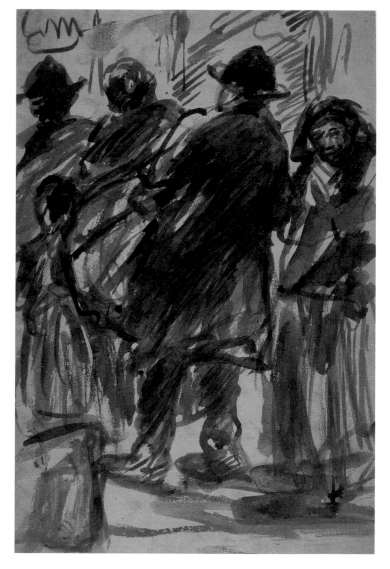

Emigrants ready for departure, 1907
ink, 20.5 x 13.1 cm
private collection

Emigrant smoking a pipe, July 1904
black chalk, 21 x 15.5 cm
private collection

Well-dressed emigrant, 1902
black chalk, 21 x 13 cm
private collection

Jewish emigrant, 26 February 1904
black chalk, 21.2 x 13.2 cm
private collection

Belgian Immigrants

Thousands left Belgium during the nineteenth and early twentieth centuries to try their luck in the United States. Most of these immigrants were from the small agricultural villages of Flanders, the northern Dutch-speaking part of Belgium. Half of the farmers in these villages possessed less than 2.5 acres of farmland and only one cow or a couple of sheep or goats. They raised a pig, chickens and rabbits and grew their own potatoes, vegetables and some rye if they had enough land. In this way they were self-sustaining, as long as nature did not interfere; bad harvests were a disaster.

For these farmers, emigration was in fact an acceptable risk. Most made their homes in Michigan, Iowa, Ohio and Texas, though some traveled as far as California. In 1847-48, immigration became the way out of poverty sparked by the failures of the potato and grain crop because of diseases. At the same time mechanical looms were introduced, decimating the cottage industry of spinning and weaving and causing widespread poverty. The plague and cholera were prevalent.

Another reason for emigration was the army. In December 1909 the lottery system was abolished and replaced with general conscription. Young men were required to join the army when they turned twenty. The new system made service virtually a certainty. Emigration was appealing to many young men, who faced a duty tour of at least 15 months, with no pay and poor food. Many made their escape abroad, knowing that they would not be able to return.

When the influx of Eastern European emigrants into Antwerp fell off because of the bad reputation of the ships, the shipowners started to reach out for business within their own country. The Red Star Line, which already had a network of agents all over Belgium (as it had in eastern Europe), started an advertising campaign and sent agents to the villages to recruit young peasants. Most of the Belgian emigrants left their country at the port of Antwerp on a steamship of the Red Star Line sailing for New York or to another port in the U.S. The trip took 10 days or longer and was often - provided that they had enough money - immediately followed by five days on a train to the West Coast. A few who had enough money bought a second-class ticket, which spared them the misery of Ellis Island. The steerage passengers were barred from the upper decks, so as not to disturb the first and second-class passengers. The men often made the trip alone or with a brother or a fellow villager. Of the nearly 3 million passengers who emigrated via the Red Star Line, it is estimated that no more than 5 percent were of Belgian nationality.

The Lower East Side

By 1902 the living conditions of New York's Jewish quarter, the Lower East Side - already the largest Jewish community in the world - had already been chronicled by Hutchins Hapgood in his book, *"The Spirit of the Ghetto."* In the preface to his first edition (illustrated with drawings

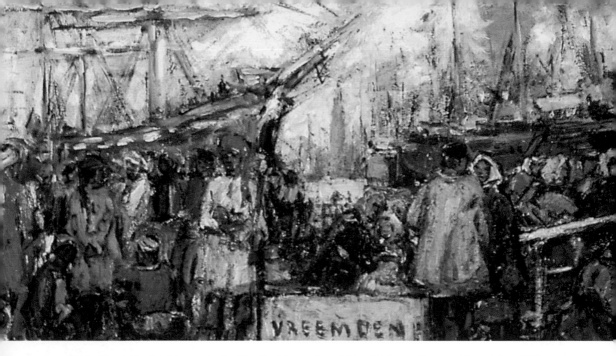

from life by Jacob Epstein) he wrote: " ...The Jewish quarter of New York is generally supposed to be a place of poverty, dirt, ignorance and immorality - the seat of the sweatshop, the tenement house, where "red-lights" sparkle at night, where the people are queer and repulsive. Well-to-do persons visit the "Ghetto" merely from motives of curiosity or philanthropy; writers treat of it "sociologically" as a place in crying need of improvement.

That the Ghetto has an unpleasant aspect is as true as it is trite. But the unpleasant aspect is not the subject of the following sketches. I was led to spend much time in certain poor resorts of Yiddish New York not through motives either philanthropic or sociological, but simply by virtue of the charm I felt in men and things there. East Canal Street and the Bowery have interested me more than Broadway and Fifth Avenue. Why, the reader may learn from the present volume - which is an attempt made by a "Gentile" to report sympathetically on the character, lives and pursuits of certain east-side Jews with whom he has been in relations of considerable intimacy..."

Around 1880 the Jewish quarter was still small, with much of the East Side under the control of Irish and German immigrants. But within a few years, the Lower East Side became the most densely populated section of New York City. By 1890 it had 522 inhabitants per acre; by 1900 more than 700. Since the streets were crammed with many small shops, the crowding was as extreme during the day as it was at night. One of the worst spots was "the Pig Market," as the Jews called it, located on Hester Street near Ludlow, where everything but pig could be bought off pushcarts and where greenhorns would mass in the morning to wait for employers looking for cheap labor.

The Lower East Side of the 1890s, said the Yiddish writer Leon Kobrin, was: "... A gray, stone world of tall tenements, where even on the loveliest spring day there was not a blade of grass. The streets are enveloped in an indefinable atmosphere, which reflects the unique light, or shadow, of

Strangers (*Vreemden*), ca. 1903
oil on canvas, 26 x 58 cm
private collection

right:
A Port Cabaret, ca. 1926
oil on hardboard, 44 x 45.5 cm
private collection

The Belgenland entering dry dock
postcard, ca. 1924
private collection

its Jewish inhabitants. The air itself seems to have absorbed the unique Jewish sorrow and pain, an emanation of its historic exile. The sun, gray and depressed; the men and women cluttered around the pushcarts, the gray walls of the tenements - all looks sad..."

The majority of Jewish immigrants who came from the 1880s through the early years of the twentieth century could not hope to escape the traumas of proletarian life. Most men worked in the sweatshops of garment industry or were peddlers. The garment industry was an ideal setting for worker exploitation: the business was seasonal, the products were capricious and child labor was rampant in an atmosphere of cut-throat competition.

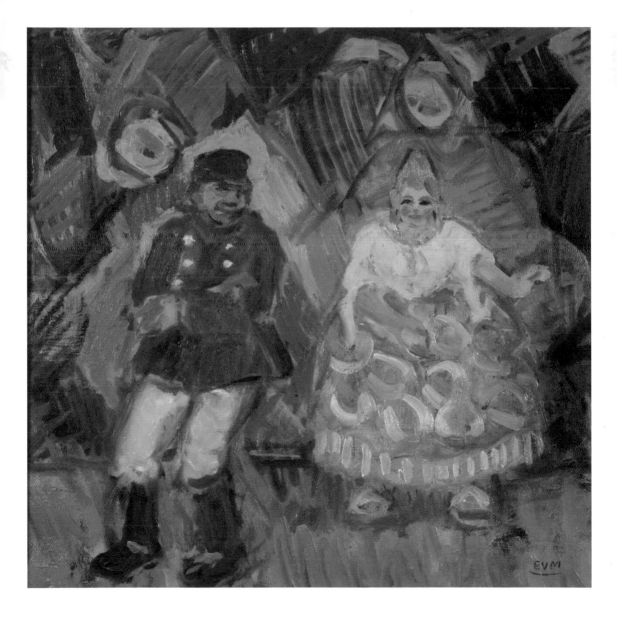

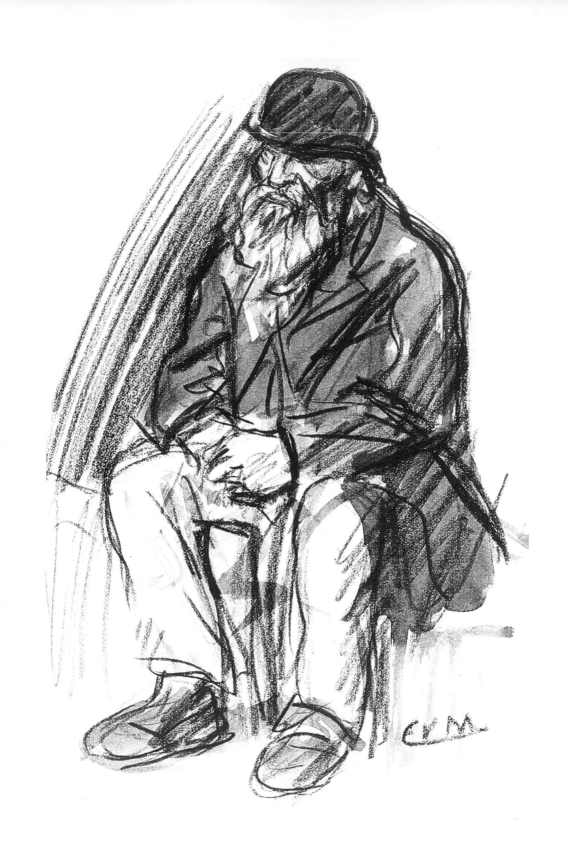

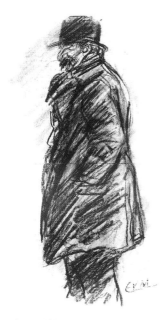

Emigrant, 1904
black chalk, 21 x 13 cm
private collection

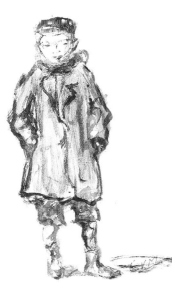

Boy, ca. 1903
black chalk, 21.1 x 16.4 cm
private collection

left:
Emigrant waiting, ca. 1903
black chalk, 15.1 x 9.4 cm
private collection

Tuberculosis, known as the tailor's disease, was the dreaded disease of the sweatshops. One immediate effect of the large-scale immigration and the mushrooming of sweatshops in the early 1880s was a sharp drop in wages. The year 1893 was especially bad. Aid organizations were forced to open soup kitchens to feed starving workers.

Greenhorns kept streaming off the ships. Immigration from eastern Europe reached a peak in 1906, when 153,748 Jews arrived in America. From 1904 through 1907, a total of 449,082 Jewish immigrants arrived; from 1900 to 1910, 1,037,000! The new immigrants often had to repeat the grueling initiation of those who arrived before 1900. Still the worst was over. Each year the physical horizon of the immigrants kept expanding.

Rapid connections with Brooklyn were made possible with the opening of the Williamsburg Bridge in 1903 and the Manhattan Bridge in 1909. The first subway to the Bronx, through the Harlem River tunnel, began operation; the first subway to Brooklyn, through the East River tunnel, opened in 1908. By about 1912 the East Side was still very overcrowded, but, as economic conditions improved, the physical betterment of the neighborhood was evident, with the building of little parks, piers for recreation, schools and libraries.

Today, the New York's Lower East Side, the primal homeland for American immigrant Jews, has lost much of its cultural texture. Yet even as the traditional neighborhood vanishes, interest in its role in Jewish cultural history is burgeoning and the Lower East Side Tenement Museum receives a steady flow of visitors.

At its peak, around 1910, the square mile area bounded by East Third Street, the Bowery, Catherine Street and the East River was home to 373,057 people, the majority of whom were Eastern European Jews. In the 2000 census, the entire population was only 91,704, nearly half of whom were of Asian descent. Only 17,200 were whites of non-Hispanic descent. Despite such shifts, for countless American Jews, the area has remained almost a holy land in memory, an old country to return to. The real old country — the cities, towns and shtetls of Europe — has long since disappeared in clouds of war and genocide. The Lower East Side became an even more powerful symbol of the bygone life of the shtetl after World War II, gaining urgency in the 1960s and 1970s with books like Irving Howe's epic, *"World of Our Fathers."*

Epilogue

In the European social art of the late 19th century, under the influence of the work by Jean-François Millet, many artists went in search of social authenticity. Vincent Van Gogh settled in the Borinage, Jozef Israëls lived among the fishermen on the coast, Max Liebermann and Henri Van de Velde headed for the countryside.

As a child of the port, Eugeen Van Mieghem lacked their restlessness. His origins determined his later art. Living in a world port, he did not need to go search for inspiration, for the world of his art was at his doorstep. Driven by youthful idealism, he left behind a unique and enduring visual record of the lives of ordinary people in a cosmopolitan seaport.

His works about emigrants are unique artistic and valuable historical artifacts that provide abiding evidence of the sympathy of a single-minded observer of people compelled to seek their fortunes elsewhere.

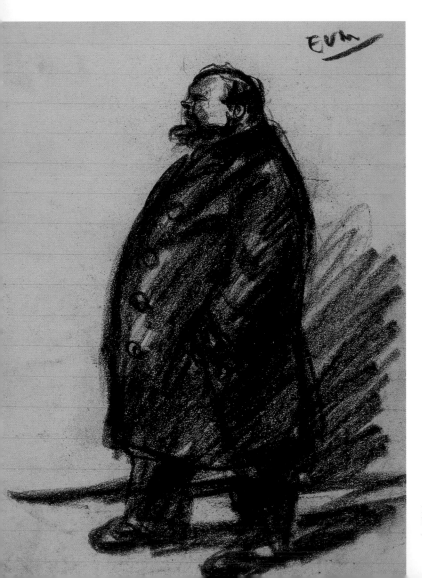

Emigrant in profile, ca. 1903
black chalk, 15.1 x 9.4 cm
Amsterdam, Jewish Historical Museum

Biography

1875 On October 1st Eugeen Van Mieghem was born in the old port of Antwerp.

1885 The Van Mieghem family opens a new inn in the part of the port called "the little island."

1892-1893 Student at the Antwerp Academy; during this time he comes into contact with the works of Van Gogh, Seurat and Toulouse-Lautrec at the exhibitions of L'Association pour l'art.

1895 Influenced by Théophile-Alexandre Steinlen.

1896 Dismissed from the Academy by Prof. Siberdt.

1897 Influenced by Edvard Munch.

1899 Frequents the anarchist youth society De Kapel. Works as loader in the port, begins relationship with Augustine Pautre, makes drawings of immigrants.

1900 Co-Founder of the artist group Eenigen.

1901 Participates in the Brussels salon, La Libre Esthétique.

1902 January 28th marries Augustine Pautre; November 11th: birth of their son Eugeen Jr.

1904 Visits museums in Amsterdam; article "An Artist of the People," about Van Mieghem appears in Pall Mall Magazine. October-November: Augustine poses as a nude model.

1905 January-February draws his ill wife; March 12th: Augustine Pautre dies of tuberculosis. July: participates at the first salon of Kunst van Heden.

1906-1909 Quiet years.

1912 First solo exhibition at the Antwerp Society of Art.

1914 Participates in a group exhibition in Cologne and The Hague. October: occupation of Antwerp by the German army.

1914-1918 Stays in the occupied city.

1919 Exhibits his war work at the Royal Antwerp Society of Art in Scheveningen.

1920 Admitted to a sanatorium where he meets Marguerite Struyvelt, who becomes his second wife. Appointed teacher at the Antwerp Academy (life drawing).

1922 Admitted to a sanatorium near Aachen (Germany).

1925 Divorces Struyvelt, his second wife.

1927 July: Admitted to Dennenheuvel Sanatorium in Ossendrecht (The Netherlands).

1929 Seriously ill. Creates still lifes.

1930 March 24th dies from an aneurysm of the coronary artery.

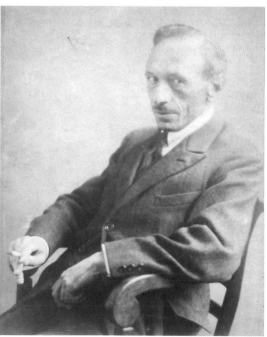

Eugeen Van Mieghem
photograph, 1925
Antwerp, Van Mieghem Museum

Bibliography

Dasnoy, Philippe, *Vingt millions d'immigrants,* Elsevier Sequoya, Paris, 1977.

di Leone Leoni, Aron, *The Hebrew Portuguese Nations in Antwerp and London at the Time of Charles V and Henry VIII,* KTAV Publishing, Inc., Jersey City, 2005.

Finch, Vernon E. W., *The Red Star Line,* Uitgeverij De Branding, Antwerp, 1988.

Hapgood, Hutchins, *The Spirit of the Ghetto,* Funk & Wagnalls, New York, 1902.

Homberger, Eric, *The Historical Atlas of New York City,* Owl Books, New York, 2005.

Howe, Irving, *The World of our Fathers,* Harcourt Brace Jovanovich, New York, 1976.

Joos, Erwin, *An Artist of the People,* volumes I, II and III, Van Mieghem Stichting - Foundation Antwerpen, Antwerp, 1993, 1996, 2001.

Moreno, Barry, *Images of America: Ellis Island,* Arcadia Publishing, New York, Charleston South Carolina, 2003.

Musschoot, Dirk, *Wij gaan naar Amerika,* Lannoo, Tielt, 2002.

Perec, Georges and Robert, Bober, *Ellis Island,* New Press, New York, 1995.

Saerens, Lieven, *Vreemdelingen in een wereldstad,* Lannoo, Tielt, 2000.

Vervoort, Robert, *Red Star Line,* Uitgeverij Pandora, Antwerp, 1999.

Landverhuizers, Antwerpen als kruispunt van komen en gaan, Exhibition catalogue, Uitgeverij Pandora, Antwerp, 2002.

Resources

www.vanmieghemmuseum.com
Eugeen Van Mieghem Museum & Foundation
www.redstarlinememorial.be
Red Star Line Museum & Memorial
www.visitantwerp.be
Tourism Antwerp
www.visitflanders.com
Welcome to Flanders
www.portofantwerp.be
Port of Antwerp, the advantages of a main port
www.alfaportantwerpen.be
Alfaport is the umbrella association of the private sector professional associations of the Antwerp port companies
www.hrd.be
Antwerp World Diamond Center
www.euronav.be
EURONAV is one of the world's leading independent crude oil tanker companies
www.exmar.be
EXMAR is a diversified and independent shipping group serving the international gas and oil industry
www.holding.cmb.be
CMB is a Belgian maritime group with its registered offices in Antwerp

Works by Eugeen Van Mieghem can be found in:

Galleries:
www.wisselingh.com
E. J. van Wisselingh & Co, Haarlem
www.wolseleyfinearts.com
Wolseley Fine Arts, London

The four Antwerp auction houses:
www.amberes.be
Amberes bvba
www.bernaerts.be
Auctioneers Bernaerts

www.campo.be
Campo Vlaamse Kaai

www.campocampo.be
Campo & Campo, Berchem